Big Bend
National Park

impressions

photography by Steve Guynes
and Richard Reynolds

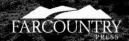

Right: Bluebonnets and bi-colored mustard.
RICHARD REYNOLDS

Title page: Pulliam Peak at sunset, Chisos
Mountains. STEVE GUYNES

Front cover: Agaves on the South Rim of the
Chisos Mountains. RICHARD REYNOLDS

Back cover: Longspur columbines in the Chisos.
STEVE GUYNES

ISBN 10: 1-56037-286-9
ISBN 13: 978-1-56037-286-8

Photography © 2004 by Steve Guynes and Richard Reynolds
© 2004 by Farcountry Press

For more information about our books, write Farcountry Press, P.O. Box 5630,
Helena, MT 59604; call (800) 821-3874; or visit www.farcountrypress.com.

Created, produced, and designed in the United States.
Printed in China.

16 15 14 13 12 3 4 5 6 7

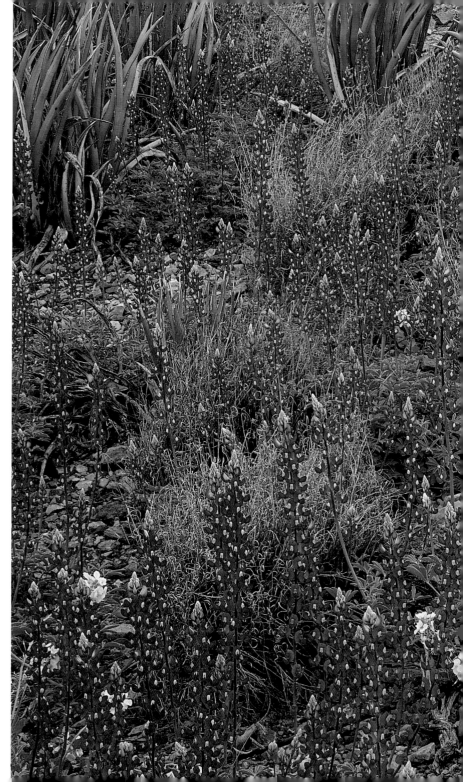

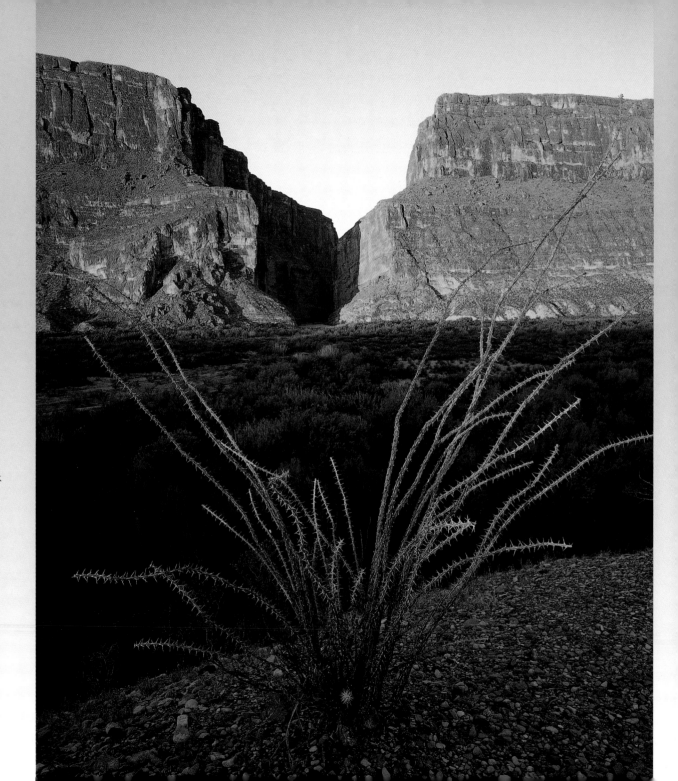

Santa Elena Canyon at dawn. The Rio Grande carved this seven-mile-long canyon through thick layers of limestone.
STEVE GUYNES

When Big Bend National Park was dedicated in June of 1944, it was touted as Texas's gift to the nation. That idea is as valid today as it was then, but, in truth, the nation has yet to truly realize Texas's gift. Today, Big Bend National Park remains something of a secret—a vast treasure trove of charm, beauty, and mystery, mostly undiscovered.

Named for the Big Bend of the Rio Grande that gives Texas its unusual and distinctive shape, the Park protects 801,000 acres of pristine Chihuahuan Desert. Within that acreage lies the only wholly enclosed mountain range in any national park, the Chisos Mountains, and within this volcanic range lie coniferous forests, springs, and alpine meadows, making the Chisos a mountainous island in the surrounding desert.

Many misperceptions exist about this area. Visitors come here uneasy about the dangers of a desert wilderness, especially the wildlife. While it's true that Big Bend has its share of what wildlife biologists jokingly call "charismatic mega-fauna"—mountain lions, bears, coyotes, bobcats, rattlesnakes, and javelina—they are hardly the dangers some imagine them to be. The real dangers are the ones inherent in any wilderness, the ones brought on by lack of preparation or inexperience: dehydration, heat exhaustion, hypothermia. Yet wilderness would not be wilderness without an element of risk—one of the reasons people frequent the Park is to test themselves in that arena, to hike where help is not a phone call away, to be left to their own devices to interact with and survive in nature.

And what nature we have! From the riparian zones along the river to the perfectly preserved tracts of Chihuahuan Desert to the high mountain peaks, Big Bend has it all. It remains a place to recharge one's batteries when the complications of modern life get too vexing—and for those of us fortunate enough to live here, or for those savvy enough to make annual pilgrimages, it is a place of endless wonder, a place full of marvels large and small.

Nature certainly offers its trials; it took a special breed of person—confident, independent, and courageous—to settle this state. From disenchanted and war-weary Civil War veterans who wrote "GTT" (Gone to Texas) on their cabin doors in Tennessee and Missouri to immigrants willing to pay any price for a chance at freedom and opportunity, this state was settled by people willing to face the challenges of nature. Modern-day Texans, descended from those pioneers, seem to have fewer and fewer chances to test themselves in nature's pure handiwork.

While we still like to think of Texas as a cowboy state, the reality is that the vast open spaces are disappearing; precious little public land

Rainbow cactus in bloom.
RICHARD REYNOLDS

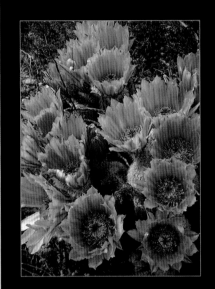

Foreword

by Mike Boren
Executive Director
Big Bend
Natural History Association

remains in this vast state, the second-largest state after Alaska. One of my favorite nephews, raised in Fort Worth and now living in Minnesota, summed it up for me nicely in a recent conversation. I asked him how a good Texas boy like him could possibly be happy in the frozen north country. He said he liked the outdoors too much to live in a state with disappearing public land. "All I can do in Texas, Uncle Mike, is ride around in a pick-up, saying 'Damn, I wish I had a ranch!'"

Well, here's your ranch, pardner, 1,200 square miles of it. Big Bend National Park is preserved, protected, and almost as wild as the day it was made. It's the essence of Texas as we like to think of it—a gift to Texas and a gift to the nation.

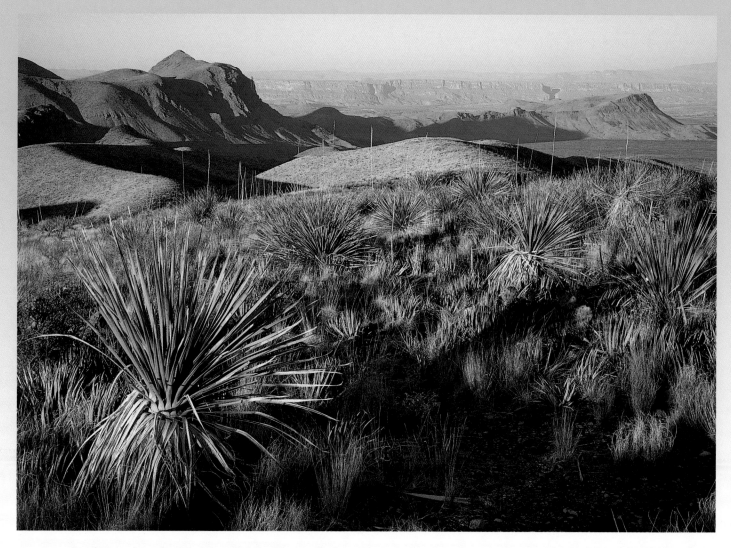

Sotol Vista, along the Ross Maxwell Scenic Drive, affords a stunning view of the western part of the park. STEVE GUYNES

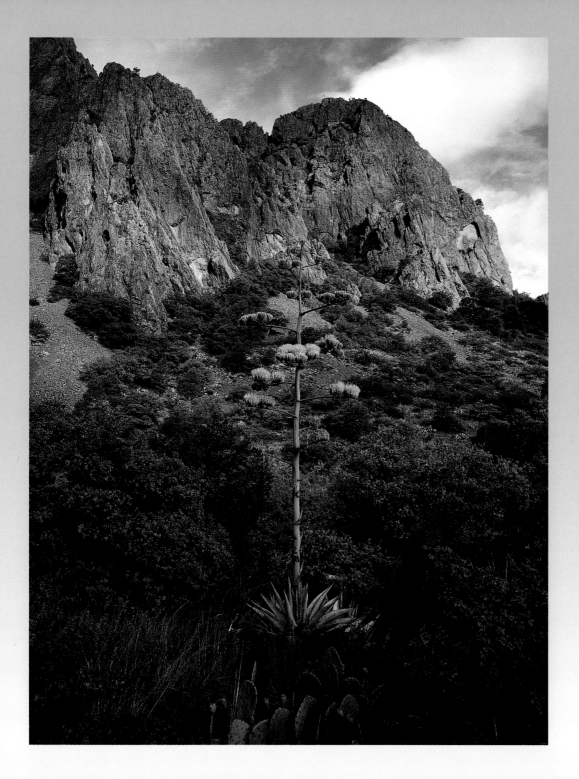

Agave abloom in Green Gulch.
These plants send up a flower-
ing pinnacle that can rise up to
twelve feet above the rosette.
RICHARD REYNOLDS

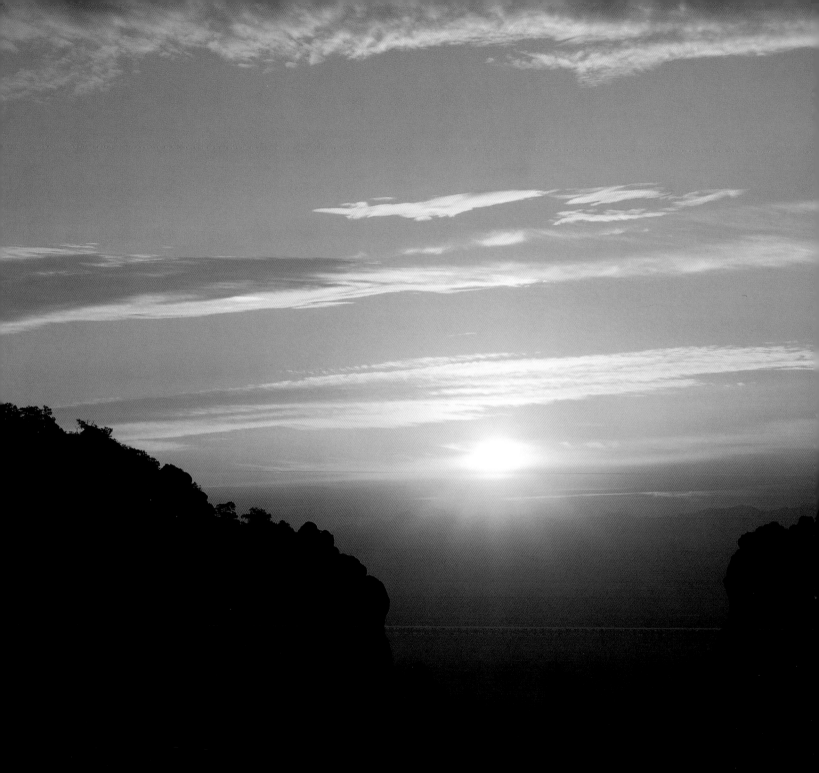

Left: Lost Mine Peak silhouetted by the setting sun. At 7,535 feet, it is the second-highest peak in the Chisos Mountains. RICHARD REYNOLDS

Below: Juniper skeleton aglow with the sun's last light on the South Rim. RICHARD REYNOLDS

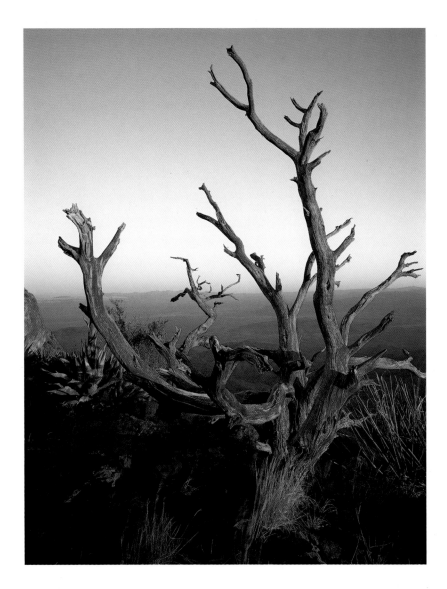

Right: The spiny canes of the ocotillo can reach up to twenty feet high; these are growing near Santa Elena along River Road. STEVE GUYNES

Below: Desert vegetation manages to make a home in the rocky terrain surrounding Glenn Draw. STEVE GUYNES

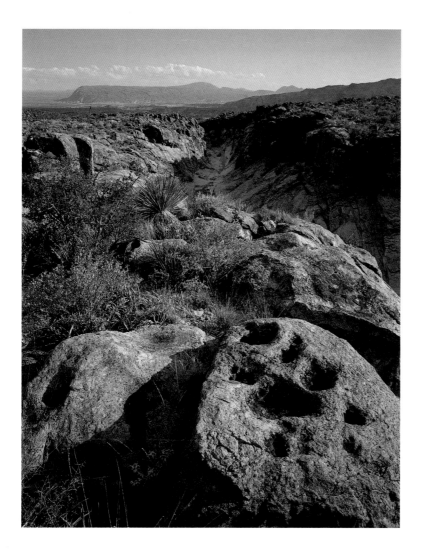

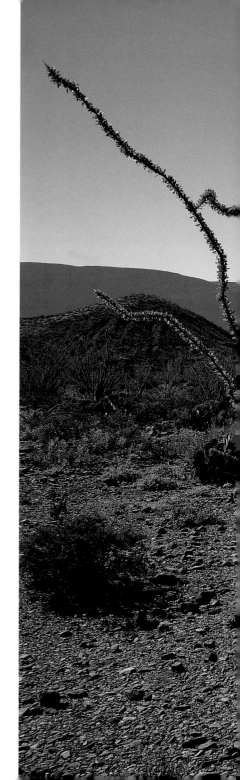

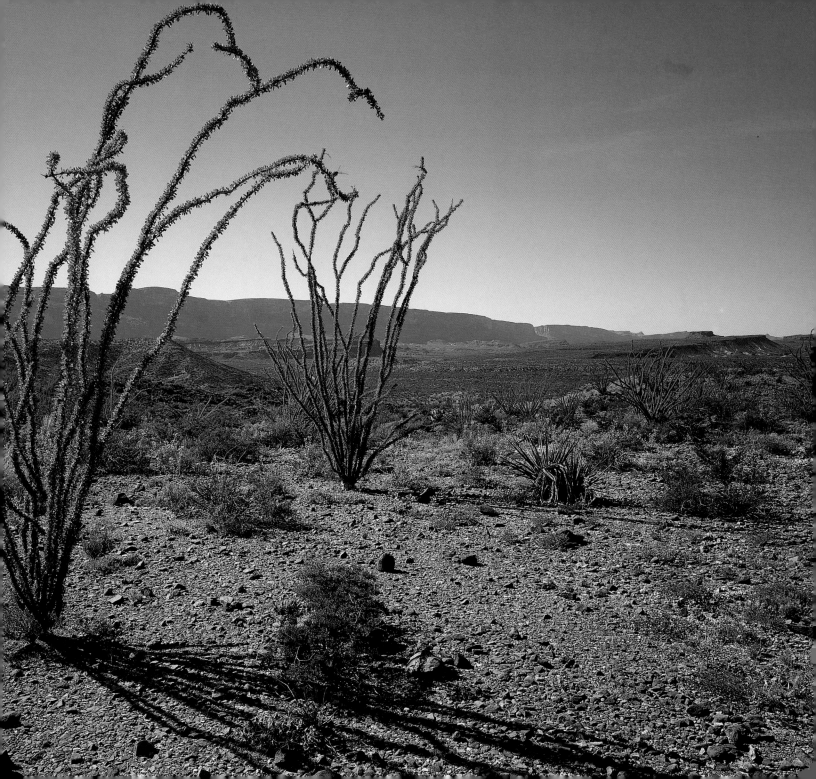

Far right: Brown-spined prickly pear cacti produce a reddish-purple fruit that is relished by javelina, pack rats, and coyotes; it's also a favorite of humans. RICHARD REYNOLDS

Right: Bouquet of prickly pear cacti. The flowers bloom in spring and turn from bright yellow to pinkish orange. RICHARD REYNOLDS

Below: This steam engine at Castolon was once used to pump water from the Rio Grande to nearby cotton fields. STEVE GUYNES

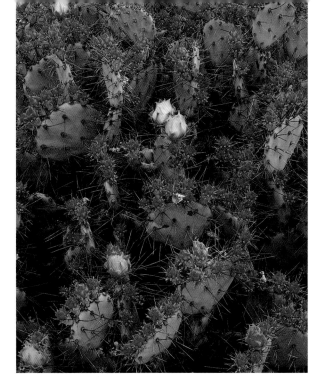

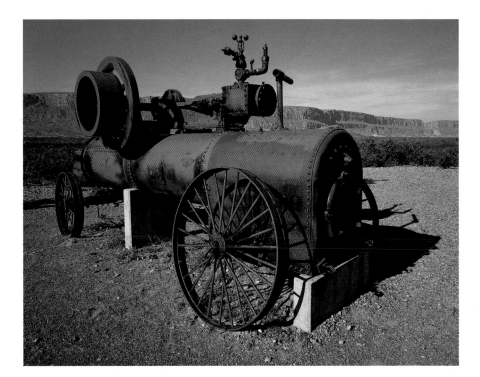

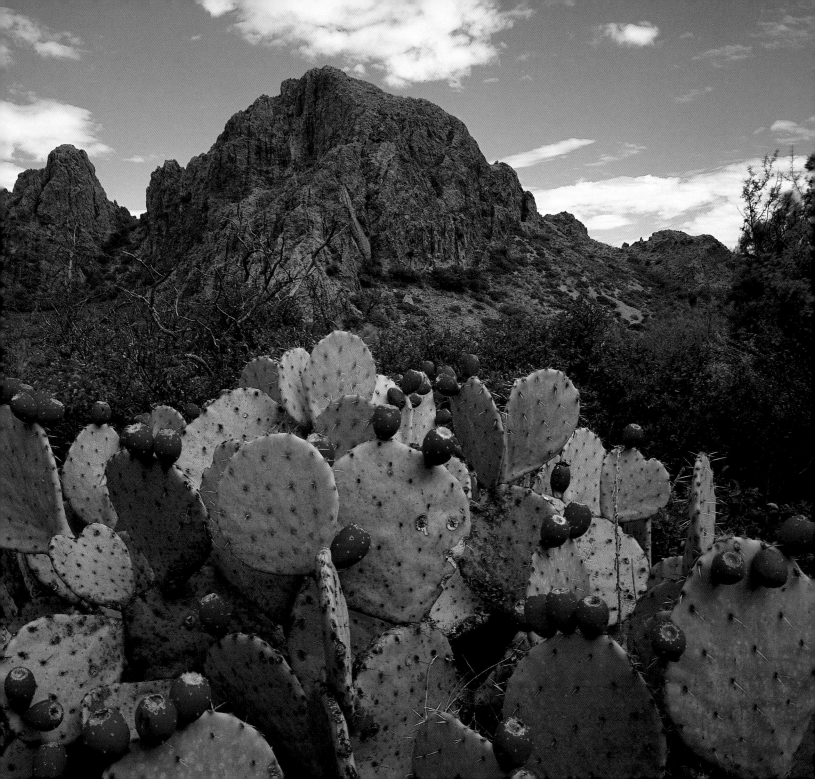

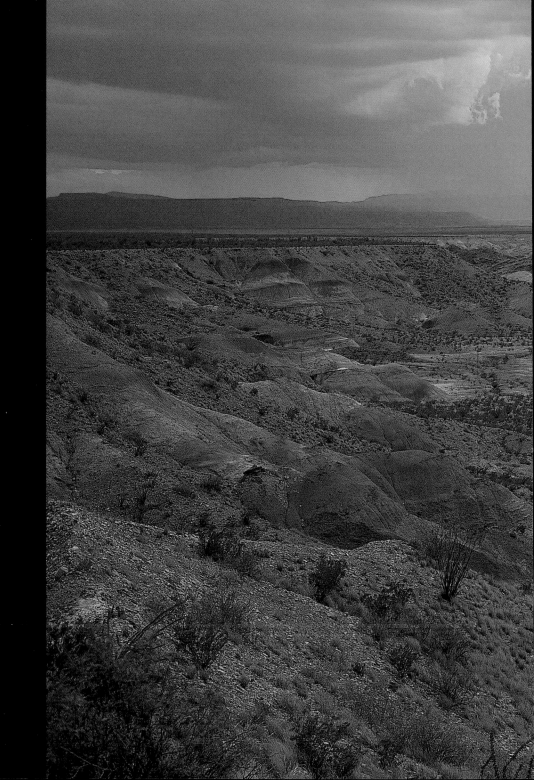

Badlands await a summer
thunderstorm.
RICHARD REYNOLDS

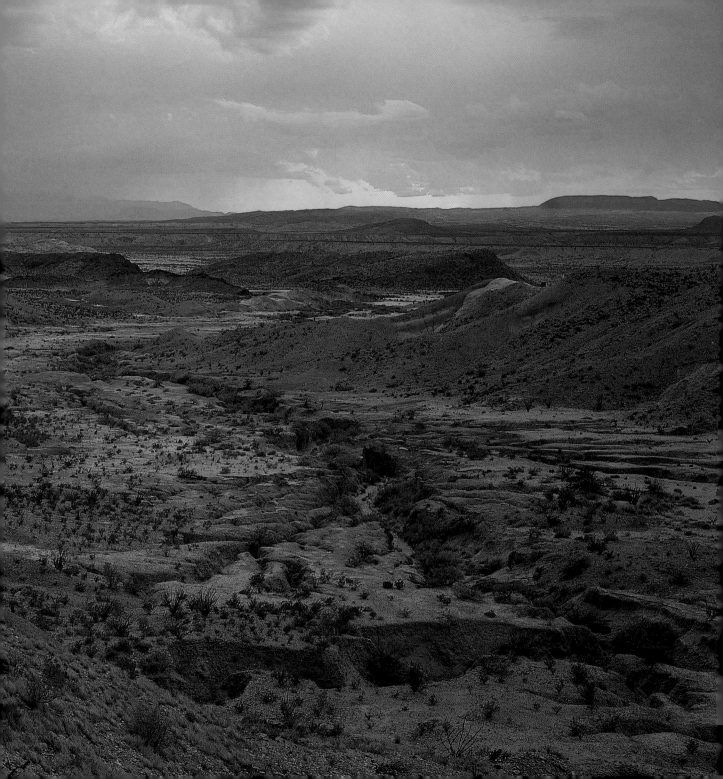

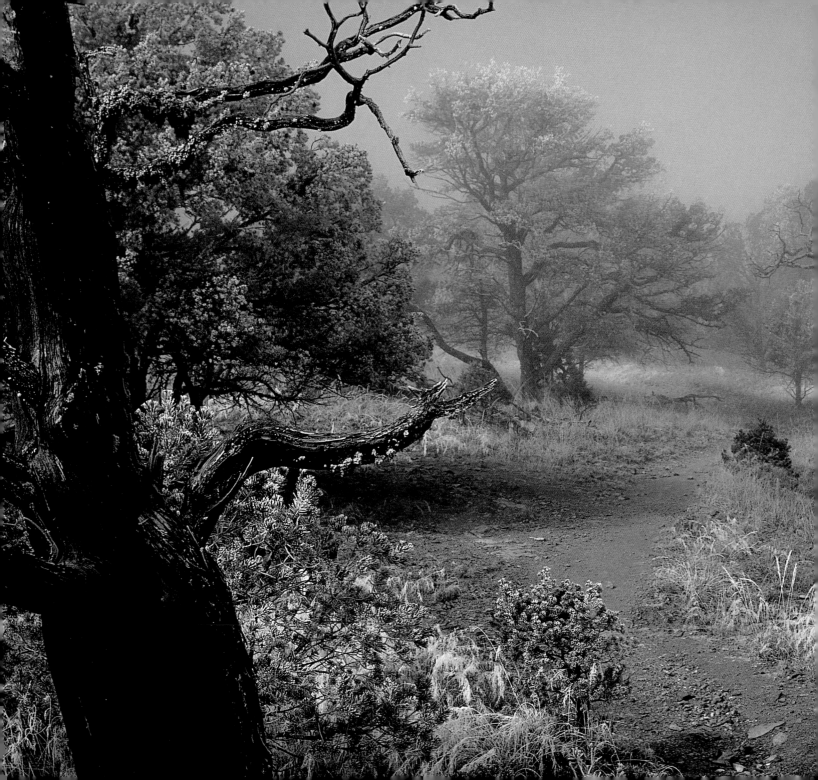

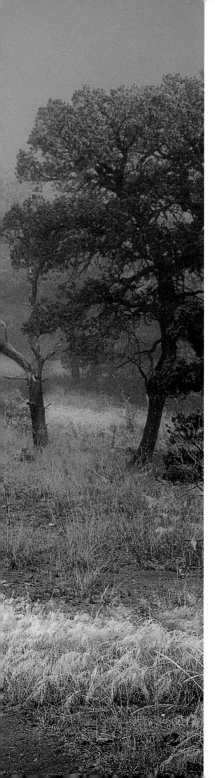

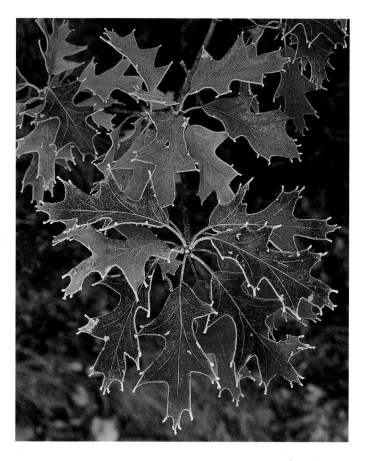

Above: Frost-tipped oak leaves in kaleidoscopic colors, Panther Pass. RICHARD REYNOLDS

Left: Hoarfrost and morning fog bring an air of mystery to the South Rim of the Chisos Mountains. RICHARD REYNOLDS

Right: Thickets of giant reed grass and common reed grass line the banks of Santa Elena Canyon. STEVE GUYNES

Below: Unusual rock formations at Glenn Springs. RICHARD REYNOLDS

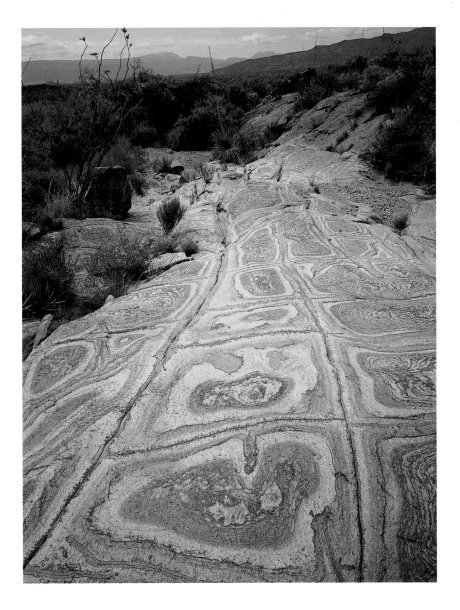

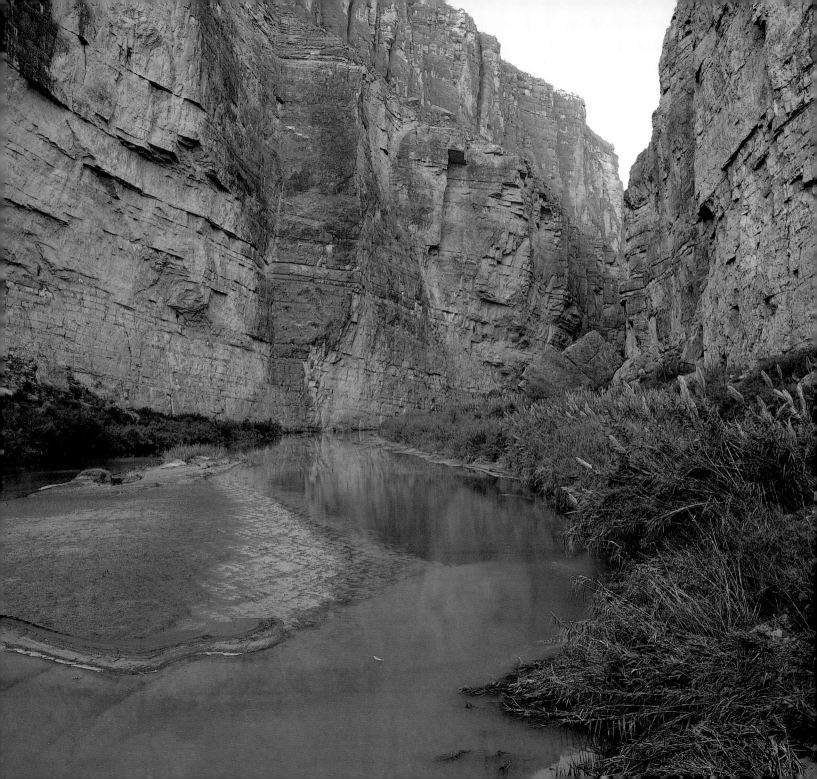

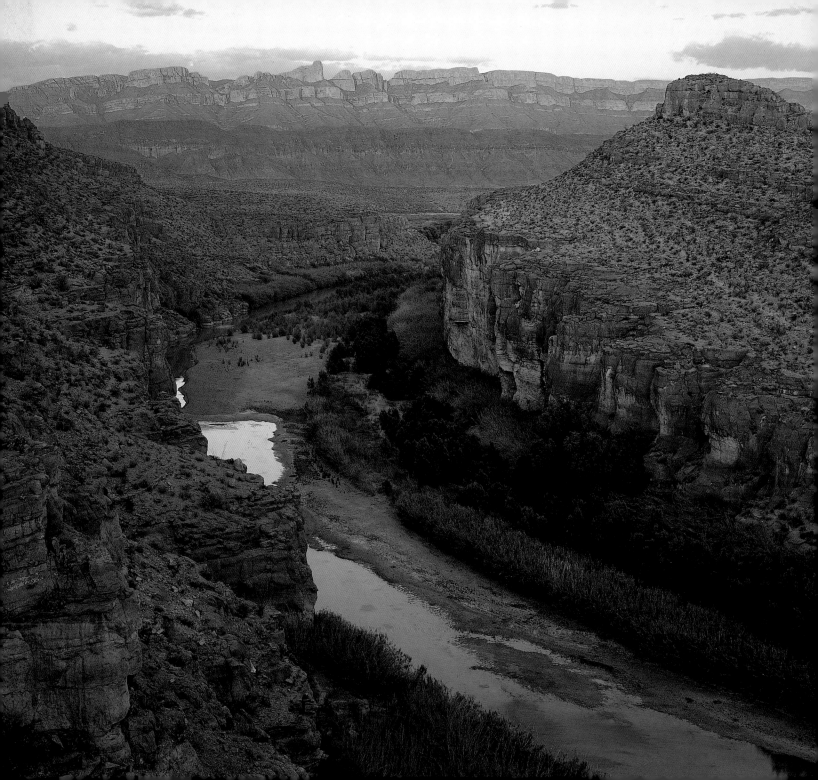

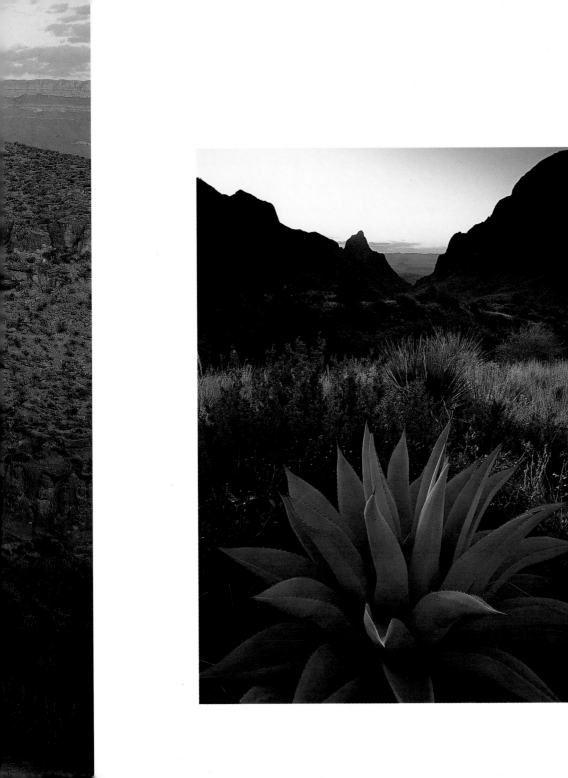

Left: Rosette of an agave is cast in blue in the cool of a Chisos Basin eve.
RICHARD REYNOLDS

Far left: The Rio Grande, at low levels, moves through Hot Springs Canyon toward the massive Sierra del Carmen.
STEVE GUYNES

Facing page: Burgeoning thunderhead over the desert. RICHARD REYNOLDS

Below. The Chisos Basin shivers under a fresh blanket of snow. RICHARD REYNOLDS

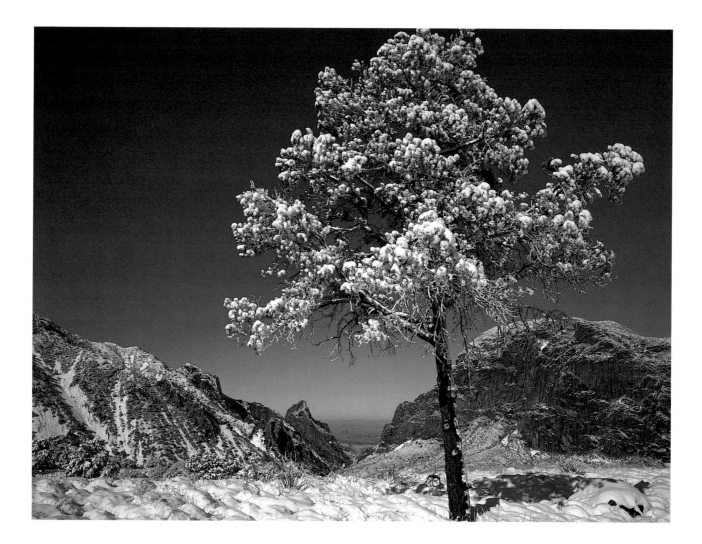

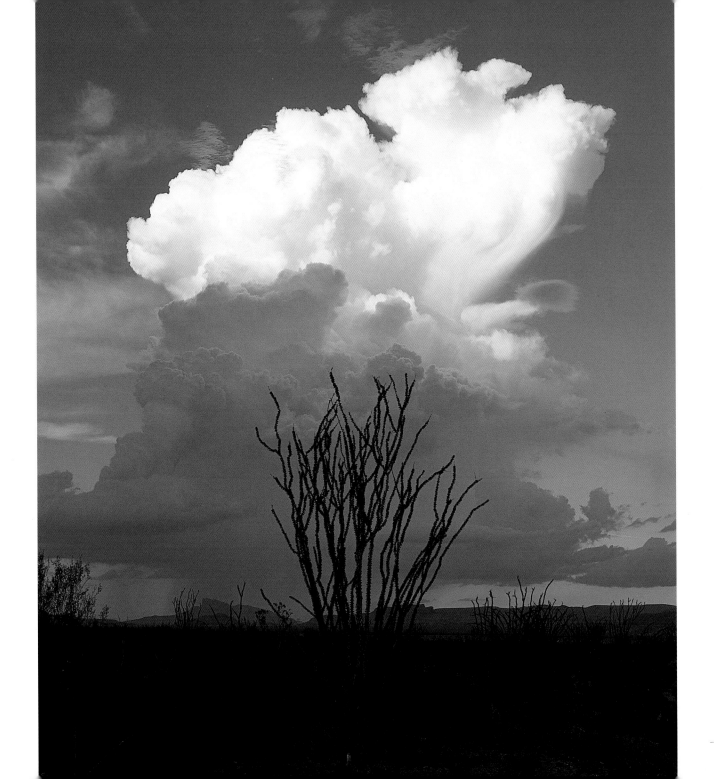

Right: Agave plants cling to the South Rim of the Chisos Mountains. RICHARD REYNOLDS

Below: Pictographs along the Chimneys Trail. KATHY ADAMS CLARK

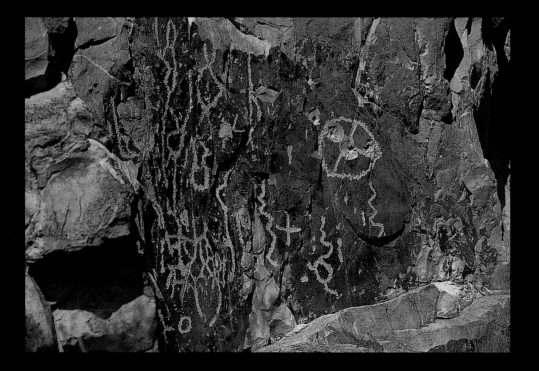

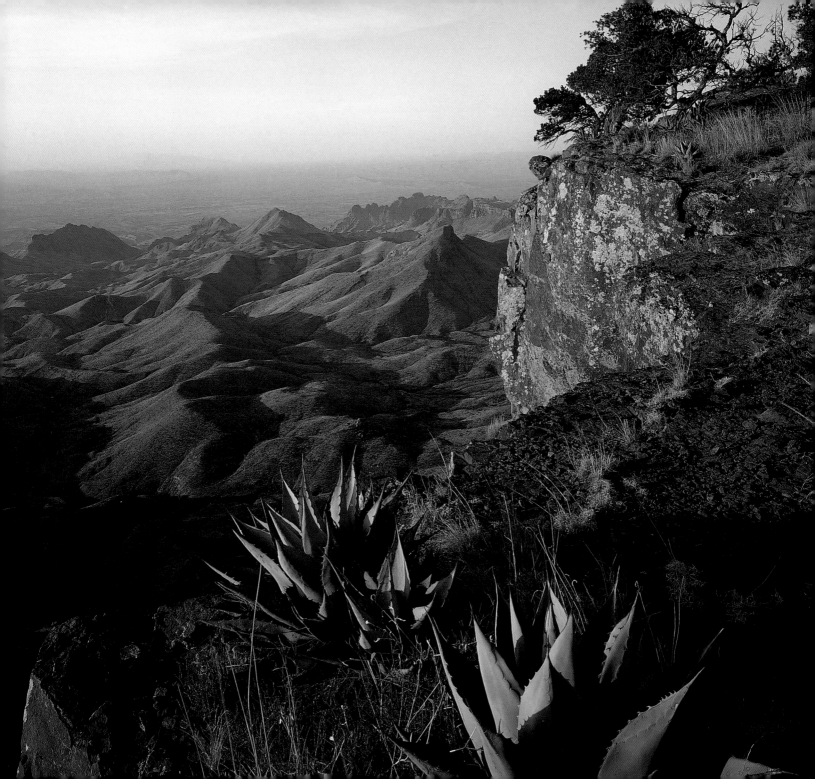

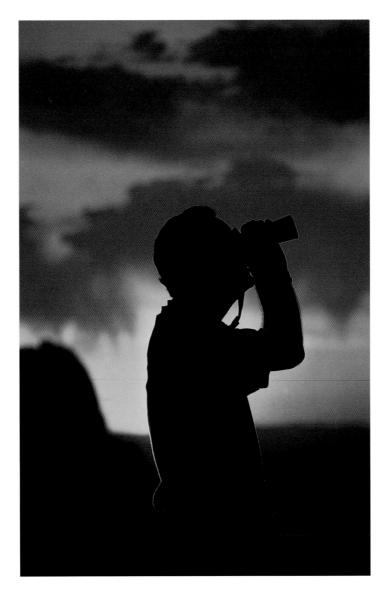

Right: Scanning a
fiery sky for creatures
on the wing.
KATHY ADAMS CLARK

Far right: To a dramatic
pastel sky, the Rio
Grande responds in
kind with a stunning
display of its own.
RICHARD REYNOLDS

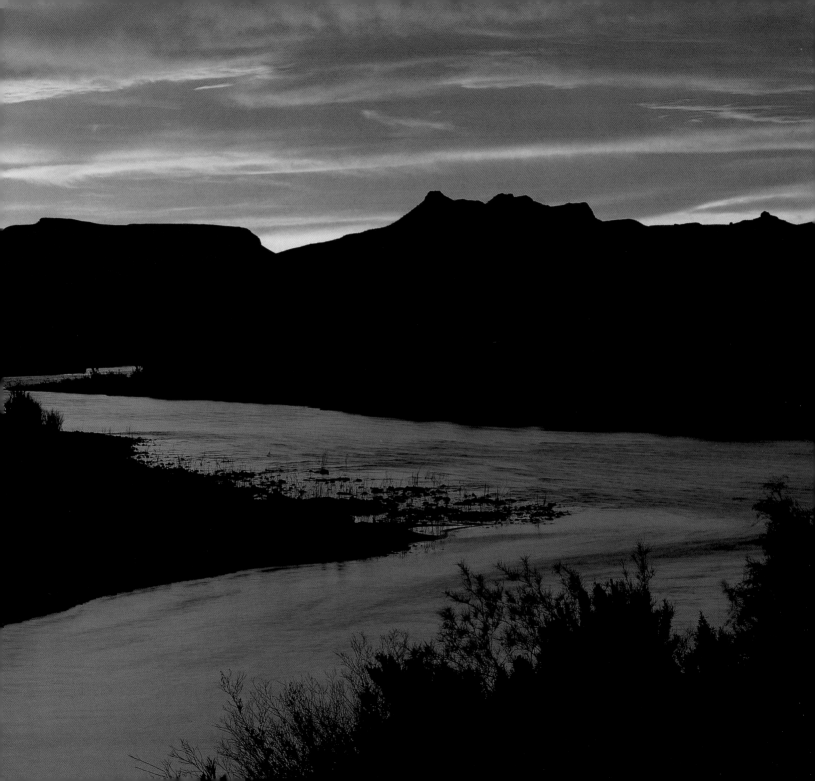

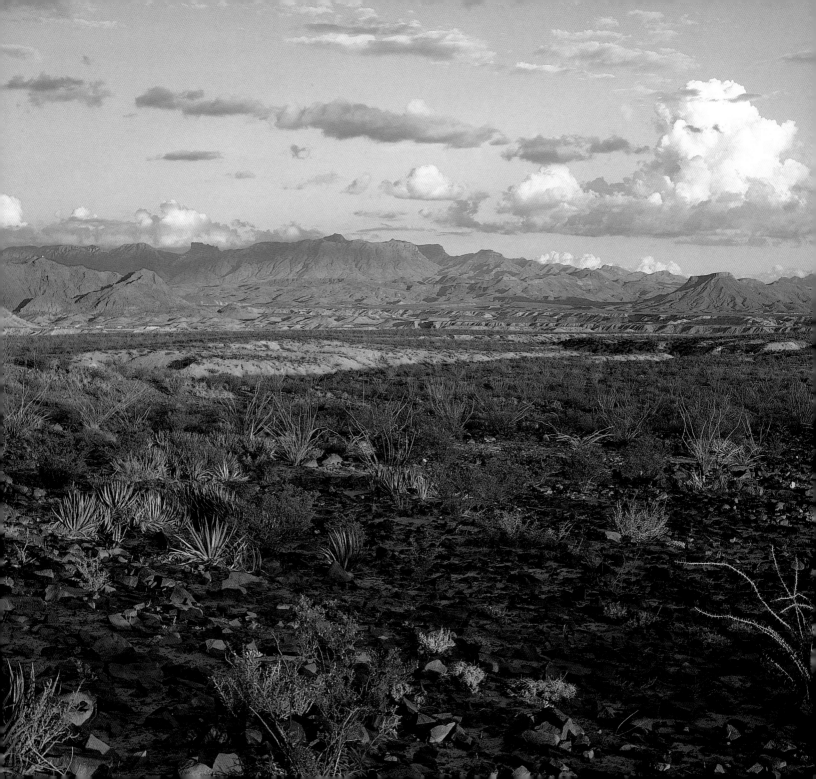

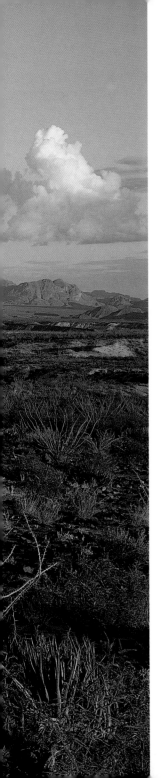

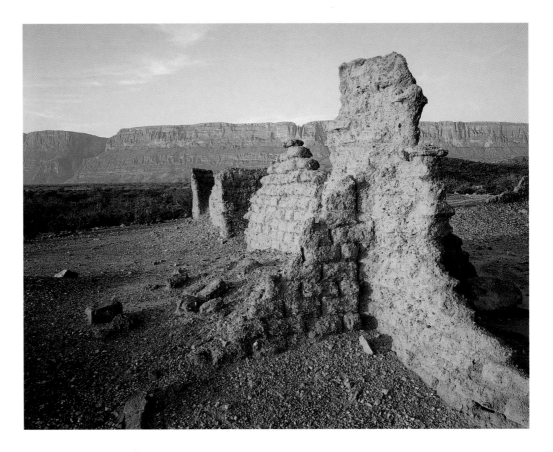

Above: Ruins of Terlingua Abajo, a farming village that provided food for area miners in the early twentieth century. STEVE GUYNES

Left: View of the Chisos Mountains from the former mining town of Study Butte. STEVE GUYNES

Right: The mysterious Tornillo Creek hoodoos, sculpted in sandstone by wind and water. STEVE GUYNES

Below: Carmen Mountain white-tailed deer grazing in the grasslands. KATHY ADAMS CLARK

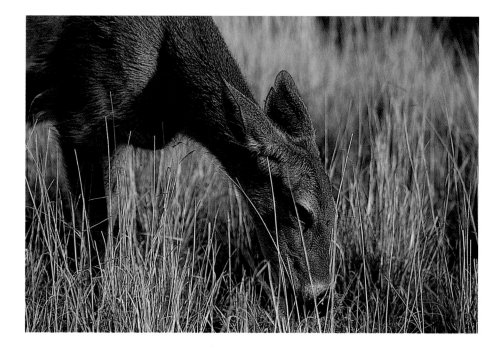

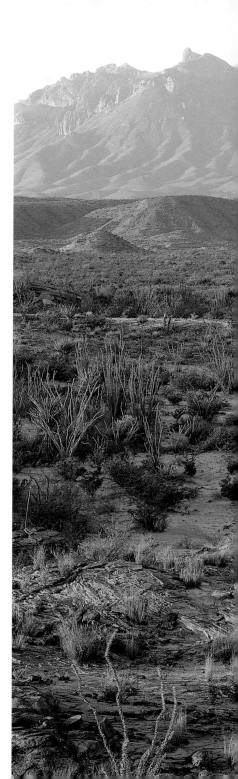

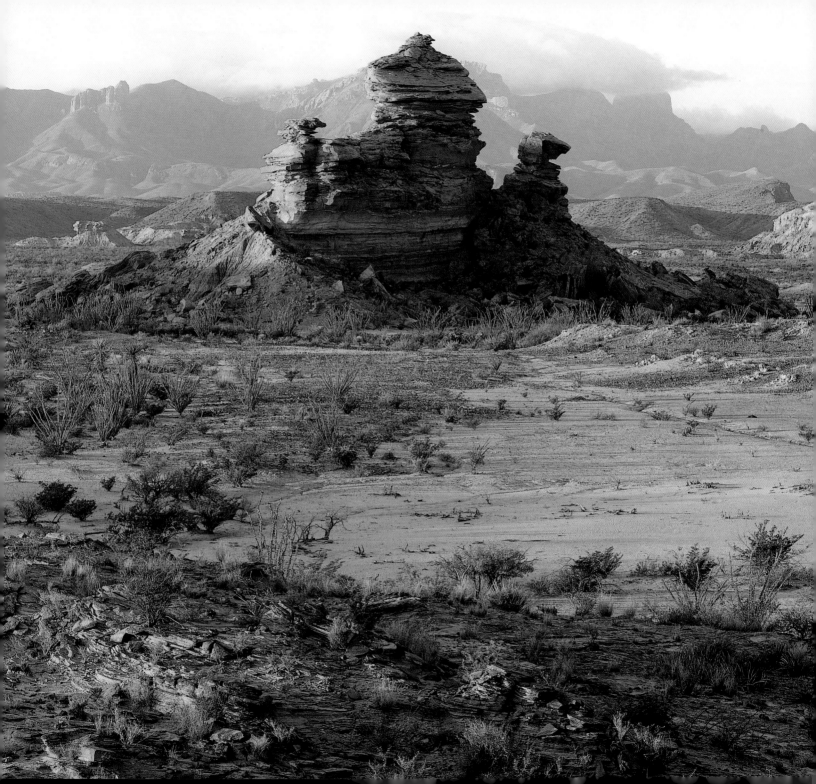

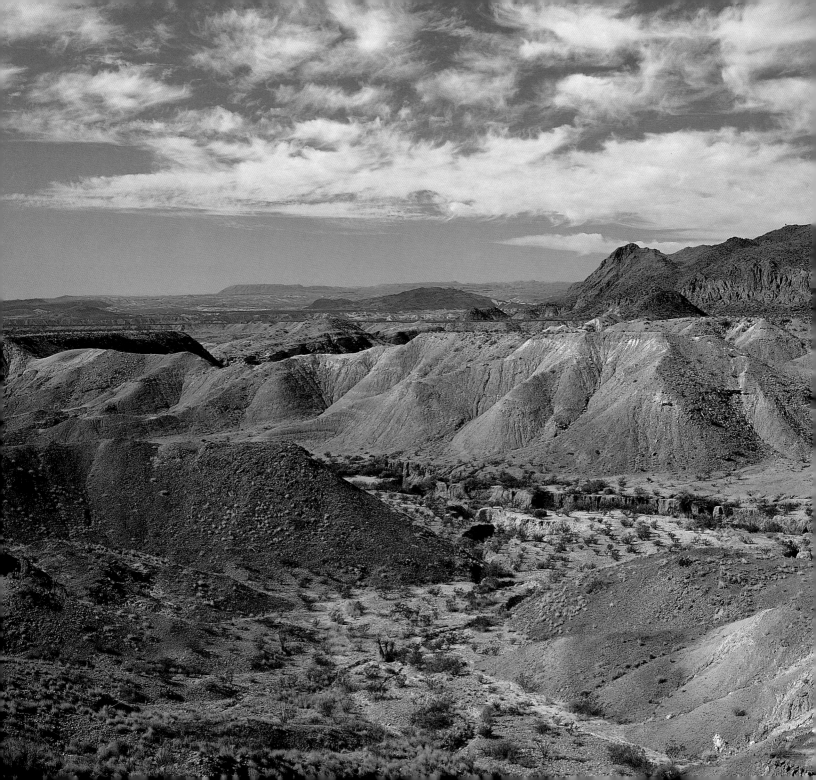

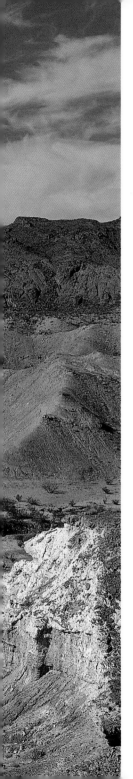

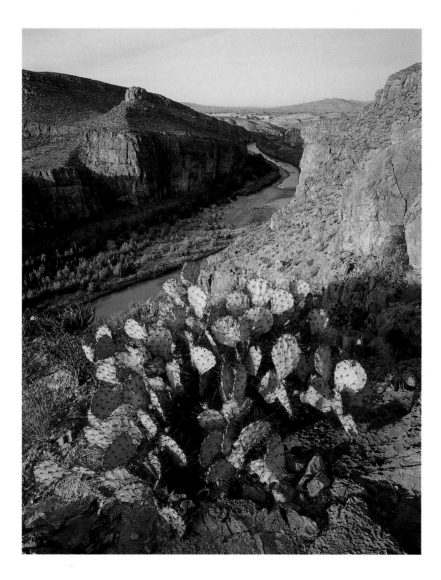

Left: The precarious perch of brown-spined prickly pear cacti above Hot Springs Canyon.
STEVE GUYNES

Far left: Maverick Mountain and the surrounding badlands, almost otherworldly in character, near Study Butte.
RICHARD REYNOLDS

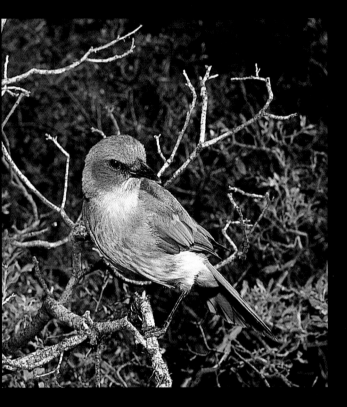

Above: The boisterous Mexican jay is a favorite of birdwatchers.
KATHY ADAMS CLARK

Right: Ocotillo and prickly pear cactus, with the dramatic
and conspicuous profile of Mule Ears in the background.
RICHARD REYNOLDS

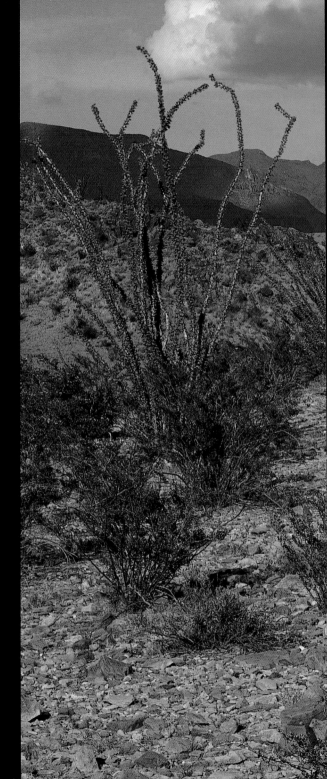

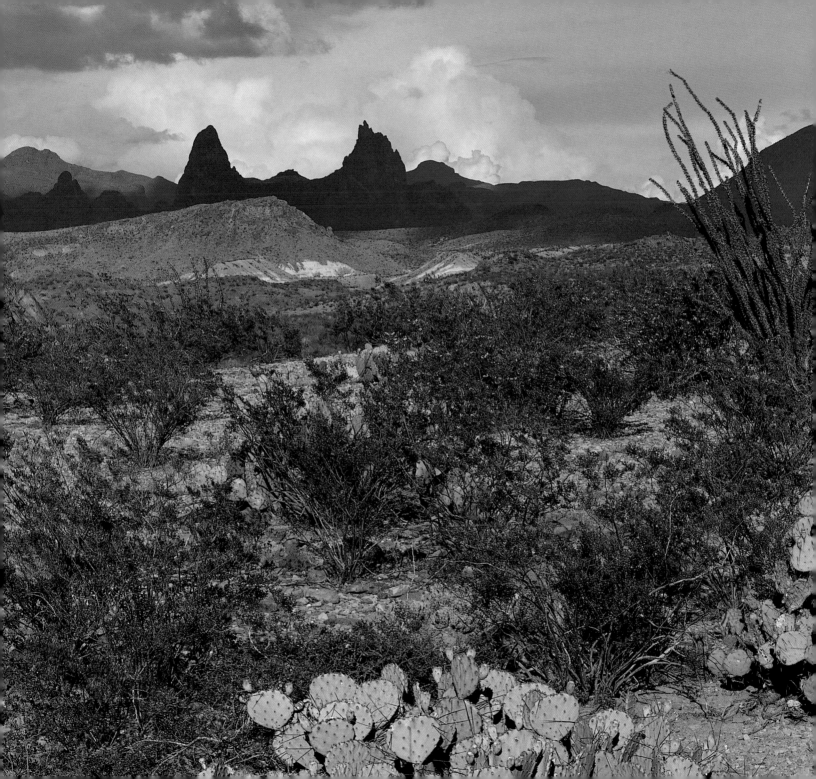

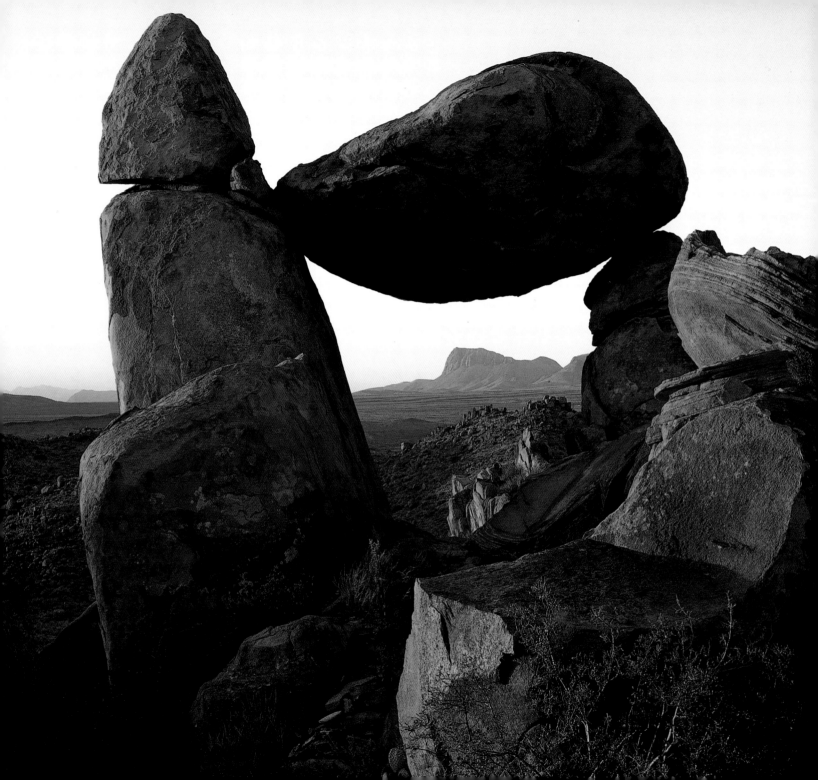

Left: Balanced rock at Grapevine Hills, one of the most photographed formations in the park. RICHARD REYNOLDS

Below: The South Rim of the Chisos Mountains basks in the setting desert sun. RICHARD REYNOLDS

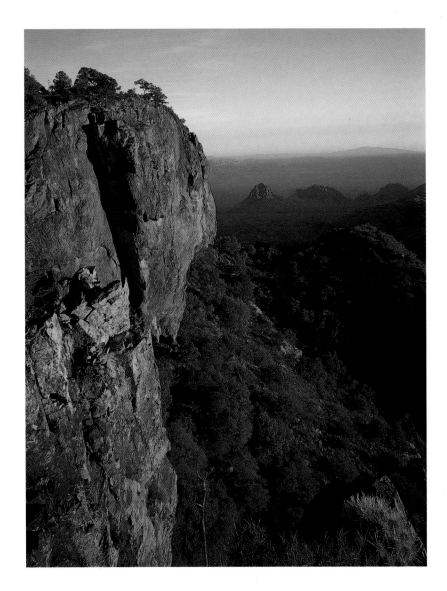

Right: The Rio Grande cuts an elegant path through this verdant stretch in Big Bend Ranch State Park. RICHARD REYNOLDS

Below: The Big Bend hechtia, a semi-succulent that thrives in Hot Springs Canyon, is actually a member of the pineapple family. STEVE GUYNES

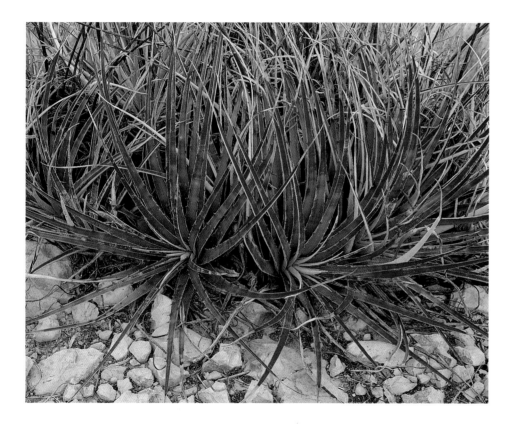

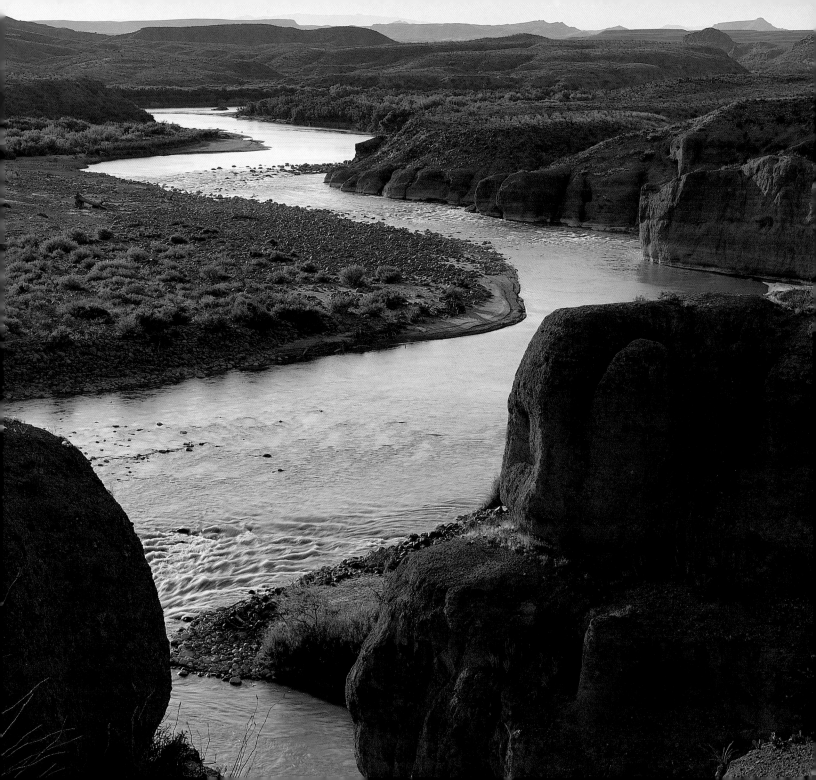

Facing page: View of the Chisos Mountains from aptly named Green Gulch. STEVE GUYNES

Right: The proud blooms of the giant dagger yucca rise above its rapier-like leaves. STEVE GUYNES

Below: Ruins of dwellings at Mariscal Mine, a mercury mine that operated intermittently from 1916 to 1942. STEVE GUYNES

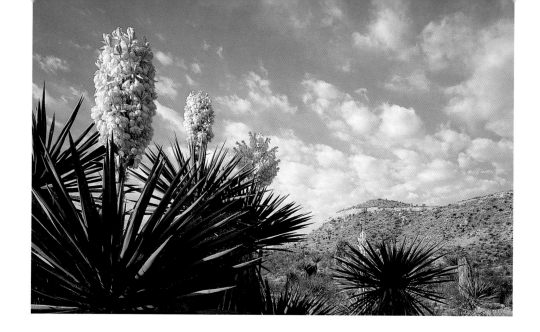

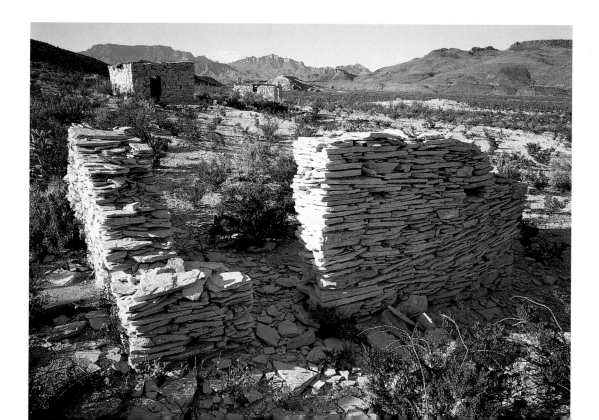

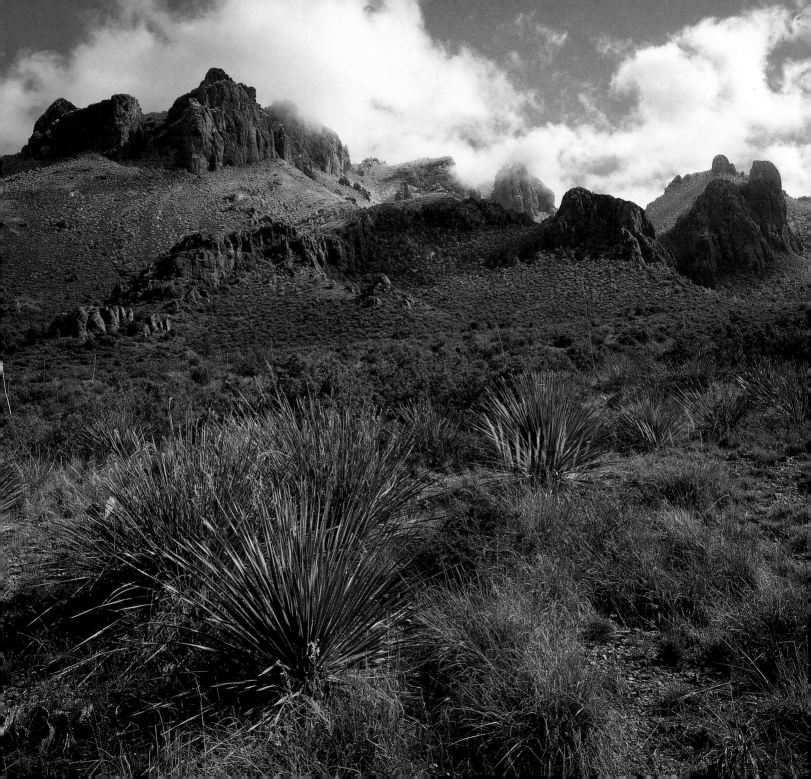

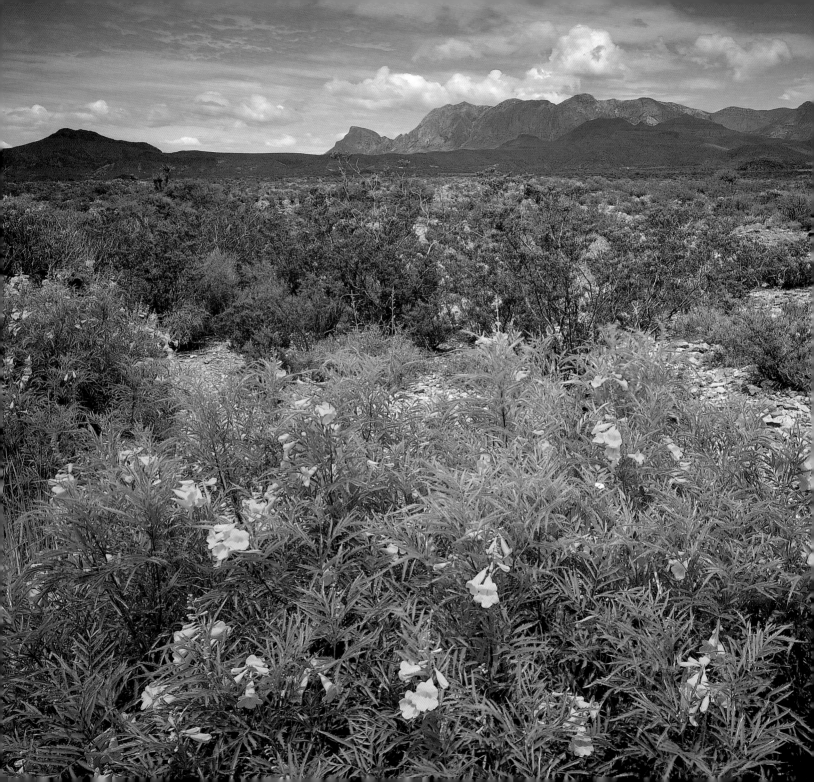

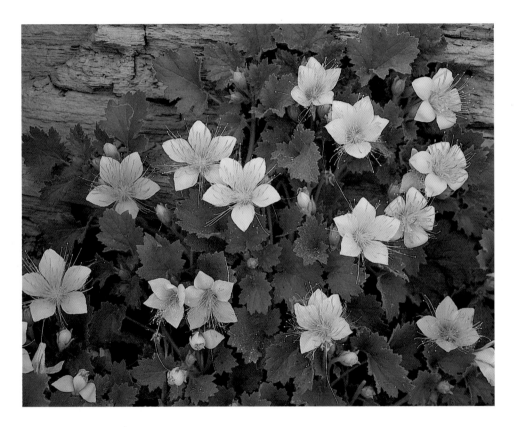

Above: Yellow rock nettle blooming near Hot Springs on the Rio Grande.
RICHARD REYNOLDS

Left: Yellow trumpet flowers herald summer with their bright blossoms.
The Chisos Mountains appear at the horizon. RICHARD REYNOLDS

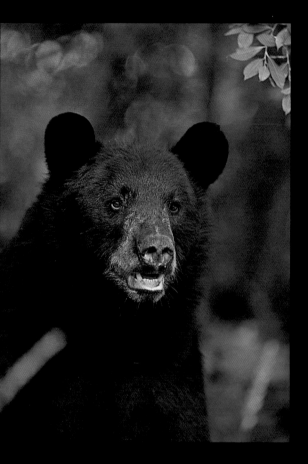

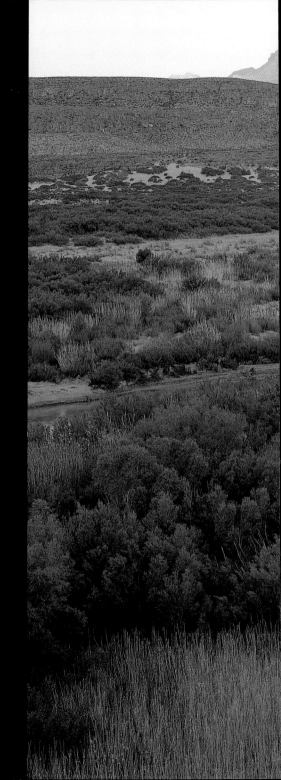

Above: Black bears were once common in the state but are now found only in West Texas; bear population is particularly strong in the park. KATHY ADAMS CLARK

Right: The Chisos Mountains, at first light, viewed from the Rio Grande Village overlook. STEVE GUYNES

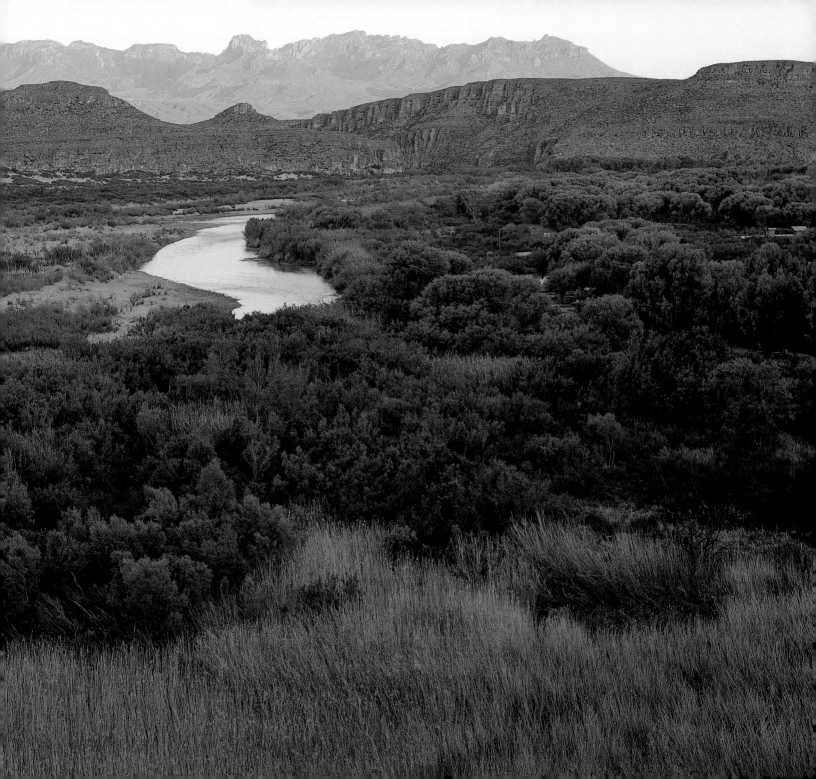

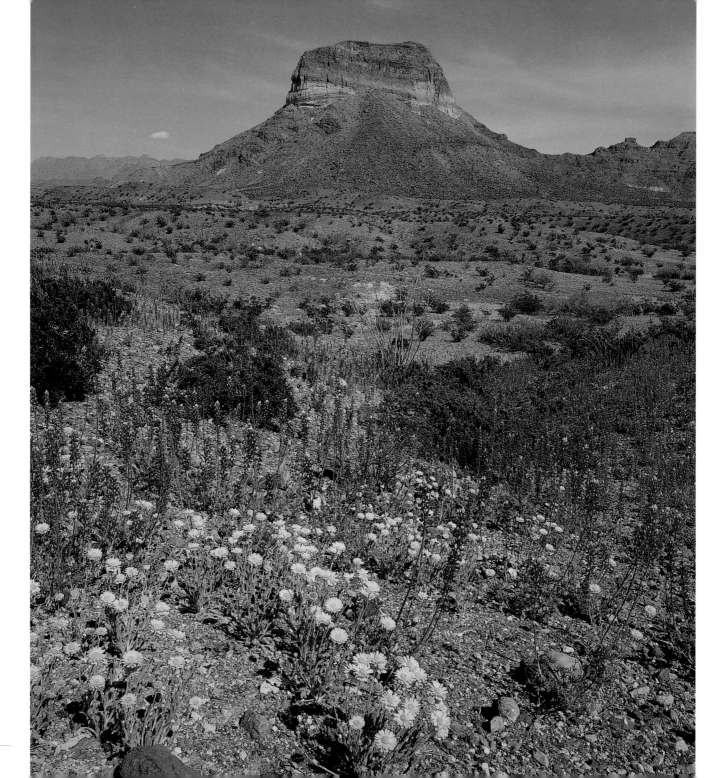

Facing page: 3,293-foot Cerro Castellan, composed of volcanic material, including ash, lava, and tuffaceous rocks. Bluebonnets and desert marigolds thrive on the surrounding terrain. STEVE GUYNES

Right: Bi-color mustard, purple mat, and parralena. RICHARD REYNOLDS

Below: Desert marigolds and verbena. RICHARD REYNOLDS

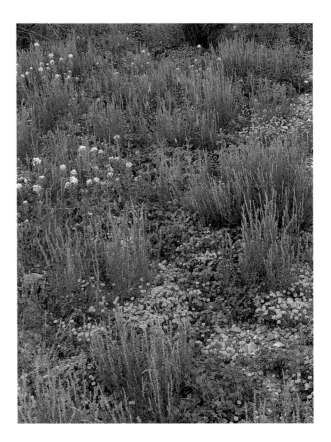

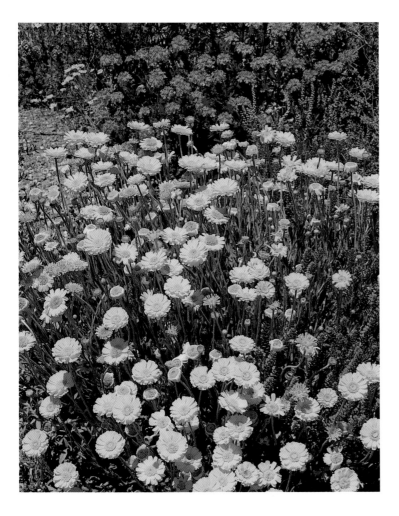

Facing page: Stipa grass aglow with afternoon light along Lost Mine Trail. RICHARD REYNOLDS

Below: Hot Springs Store was the center of this small community during the late 1800s through the 1950s. The store served as post office, market, and resort headquarters. KATHY ADAMS CLARK

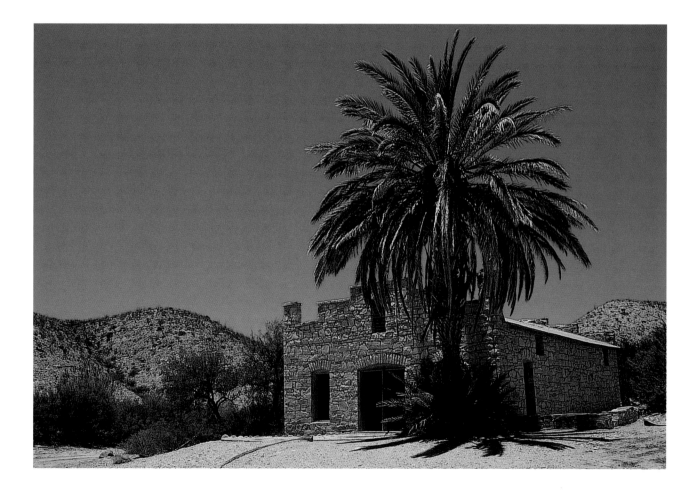

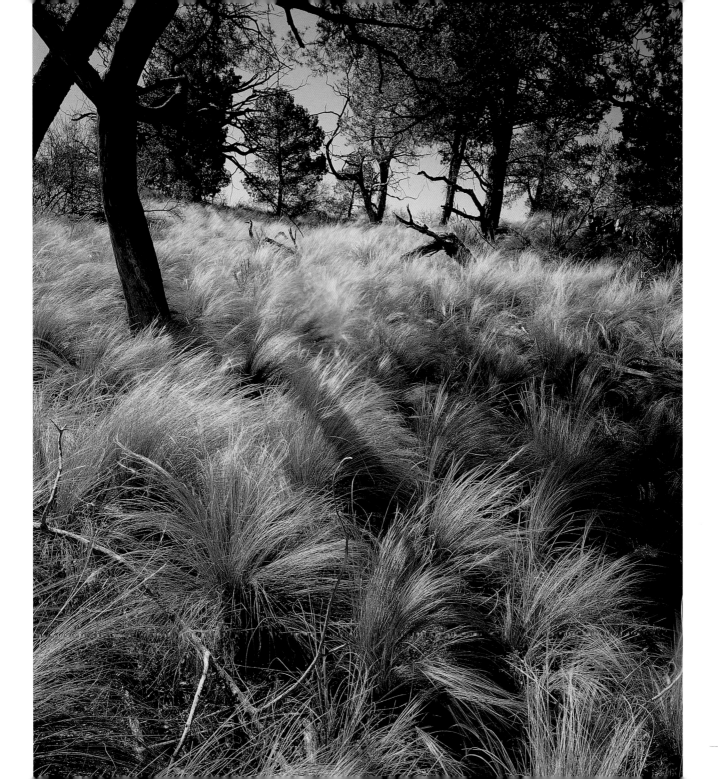

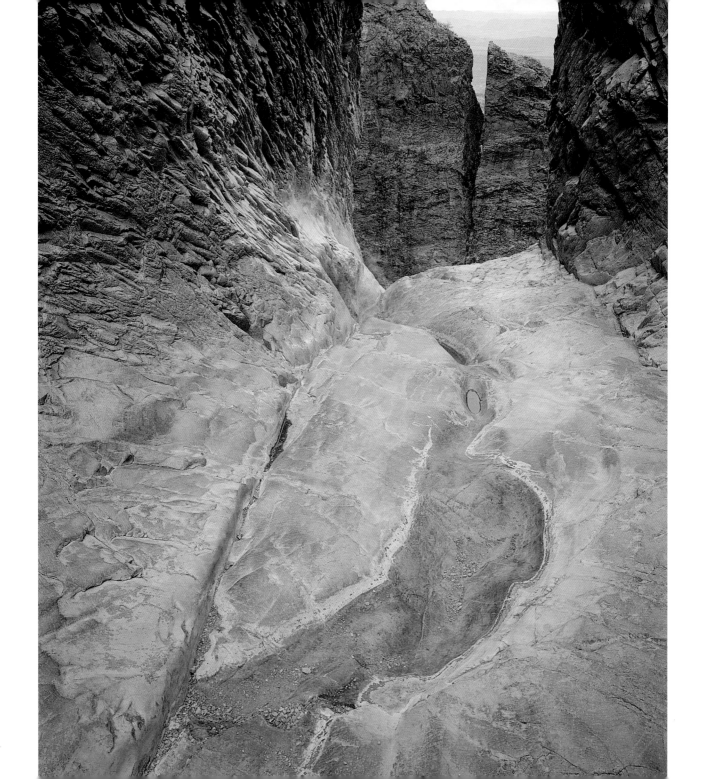

Facing page: The Window Pouroff, at the base of Window Trail in the Chisos Mountains. All the drainage from the Chisos Basin flows through this gorge, with a fall of about 75 feet from the edge of the pouroff. STEVE GUYNES

Right: Collared peccaries, or javelinas, are found in arid regions where prickly pear cactus is abundant. KATHY ADAMS CLARK

Below: Park visitors enjoying the warm spring water of Hot Springs, a 1930s resort on the Rio Grande. STEVE GUYNES

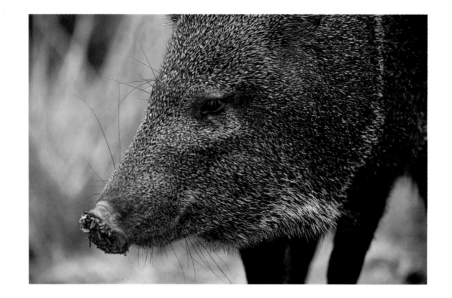

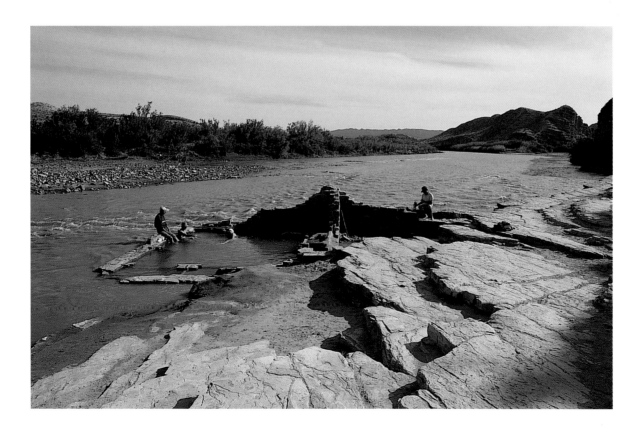

Right: The handsome eastern escarpment of the Chisos Mountains.
RICHARD REYNOLDS

Below: Oak Creek tumbles down the rocky slopes of the Chisos Basin toward the Window Pouroff. STEVE GUYNES

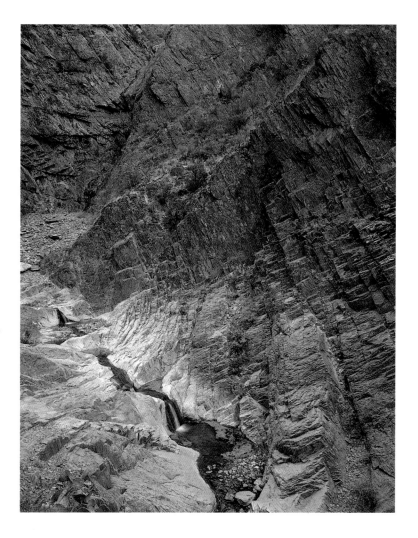

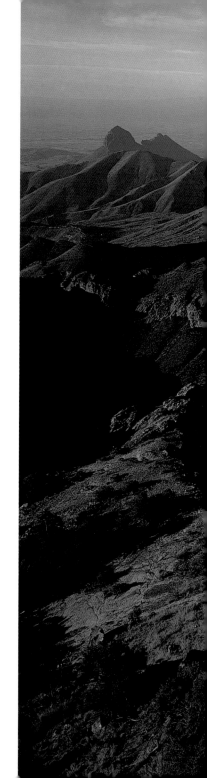

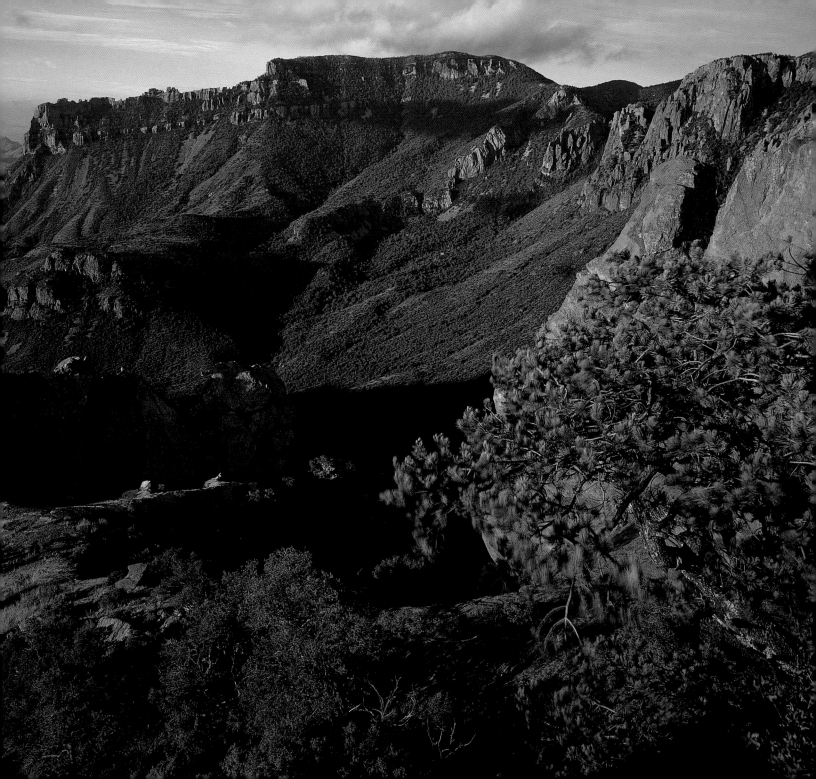

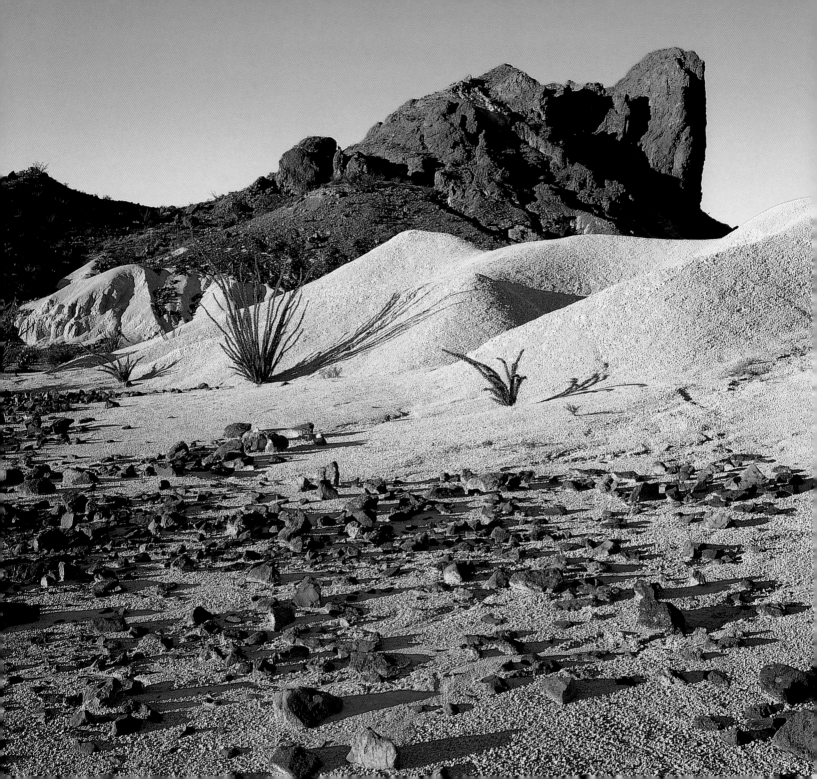

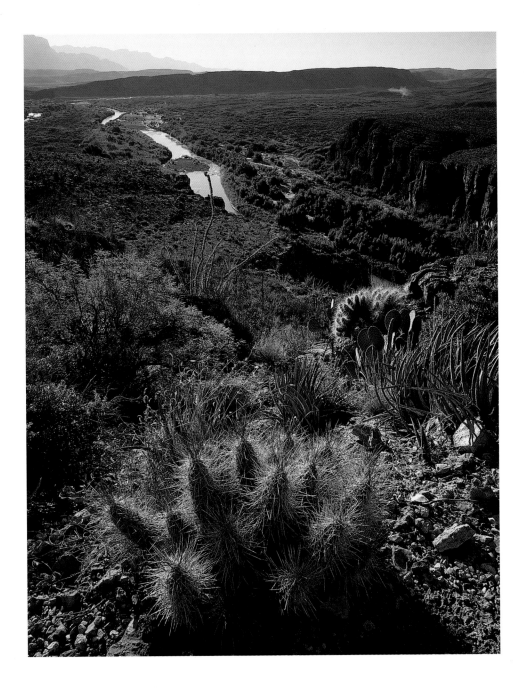

Left: Pitaya cactus, along with many other varieties of desert brush and cacti, thrives on the terrain above Hot Springs Canyon. STEVE GUYNES

Facing page: Basalt remnants and volcanic ash collect near Cerro Castellan. STEVE GUYNES

Right: One of many unusual boulder outcroppings at Grapevine Hills.
RICHARD REYNOLDS

Below: Layer upon layer of limestone are exposed as water slowly erodes
the ancient streambed at Ernst Tinaja. STEVE GUYNES

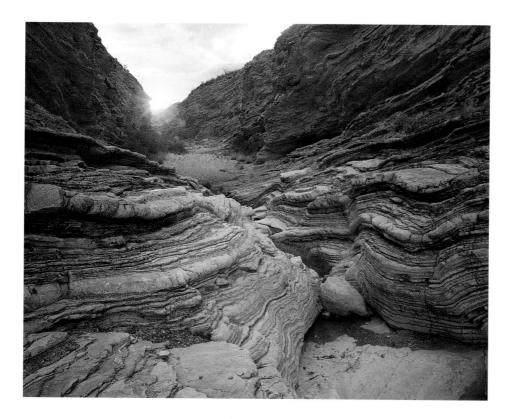

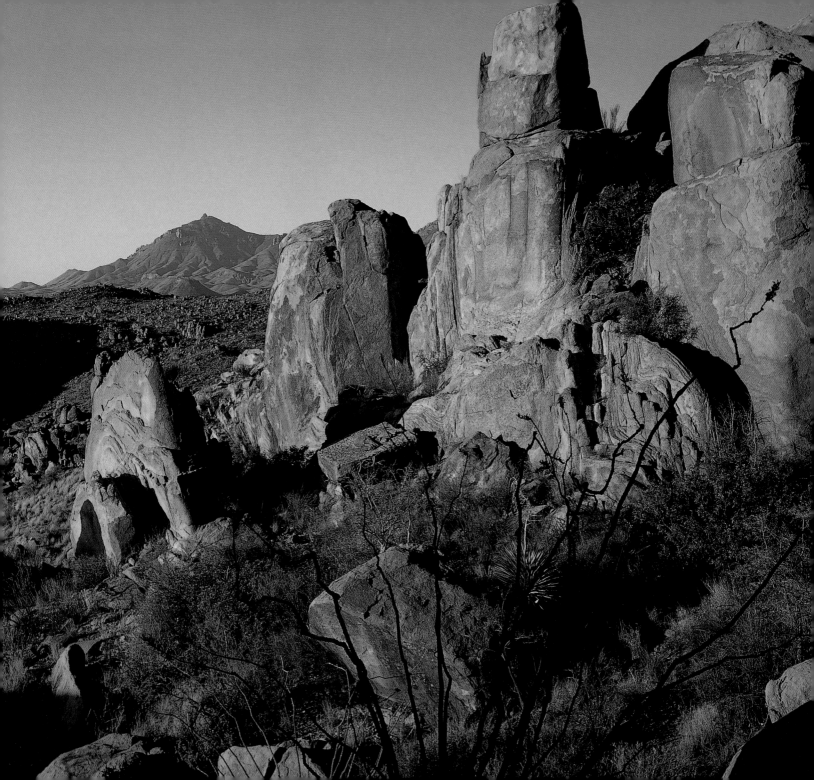

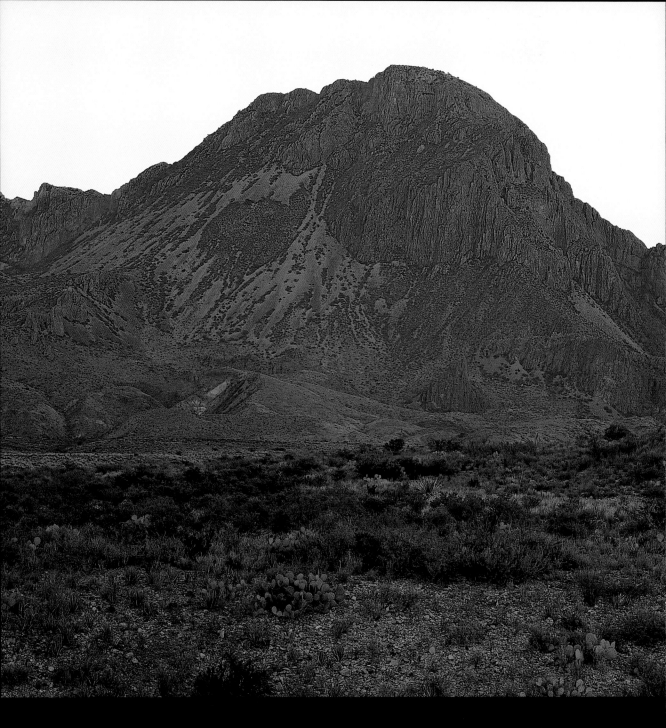

The rough western face of the Chisos Mountains is softened with evening's dying light. STEVE GUYNES

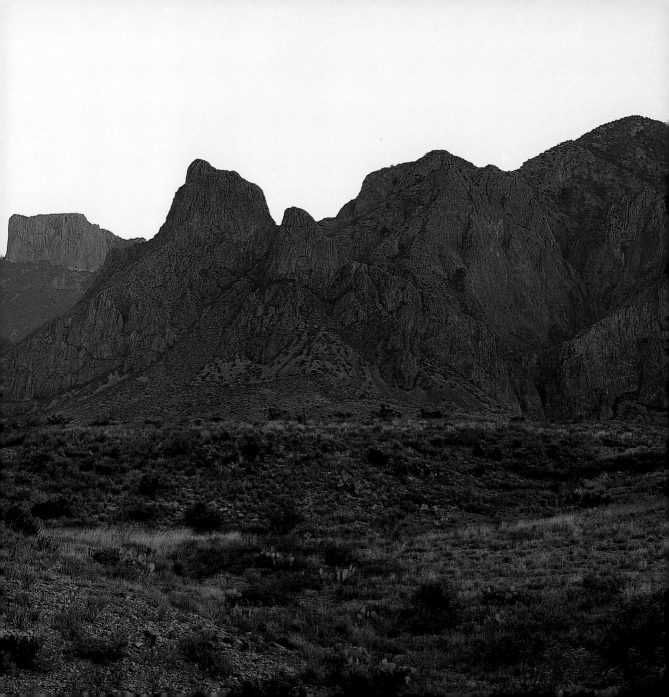

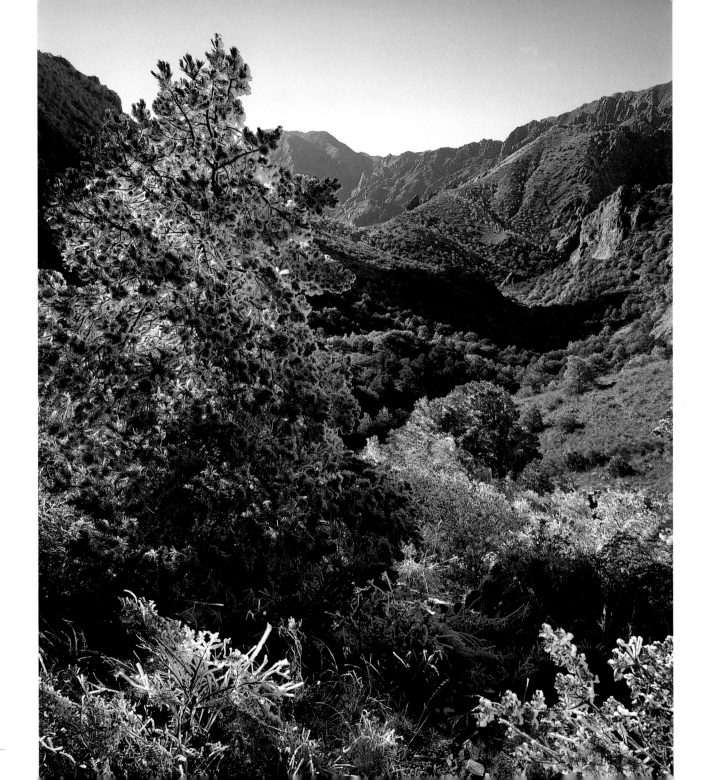

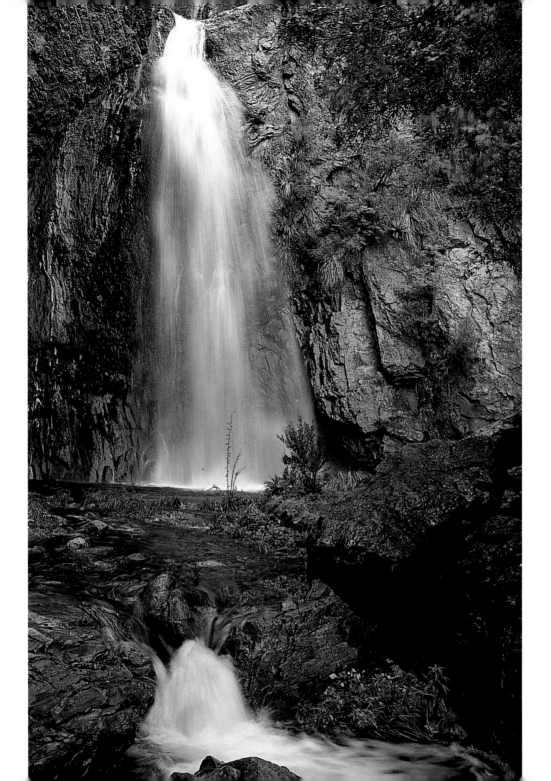

Facing page: A shock of snow grips this pinyon pine and other vegetation along Lost Mine Trail. STEVE GUYNES

Left: Heavy rains make spectacular, instant waterfalls.
KATHY ADAMS CLARK

61

Right: The rosy blossoms of cholla sweeten the Chihuahuan Desert air. RICHARD REYNOLDS

Below: A devil's head, or blue barrel cactus, is a particulary spiny, low-growing cactus that is a hazard to those who would stumble upon it. RICHARD REYNOLDS

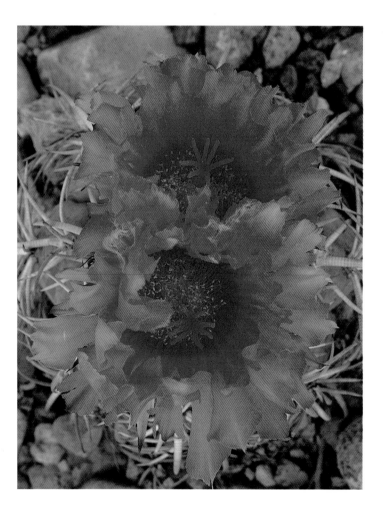

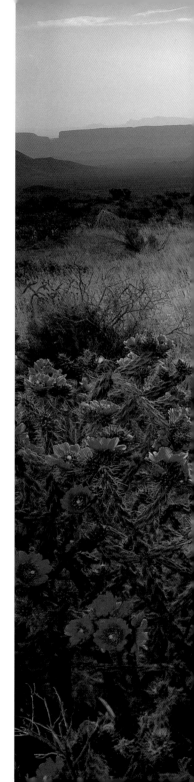

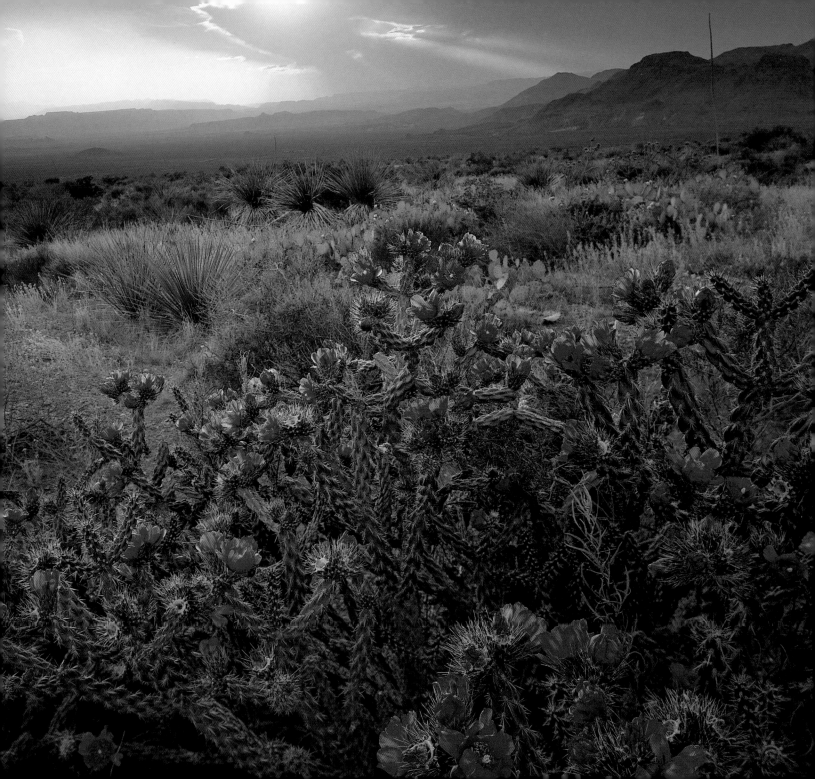

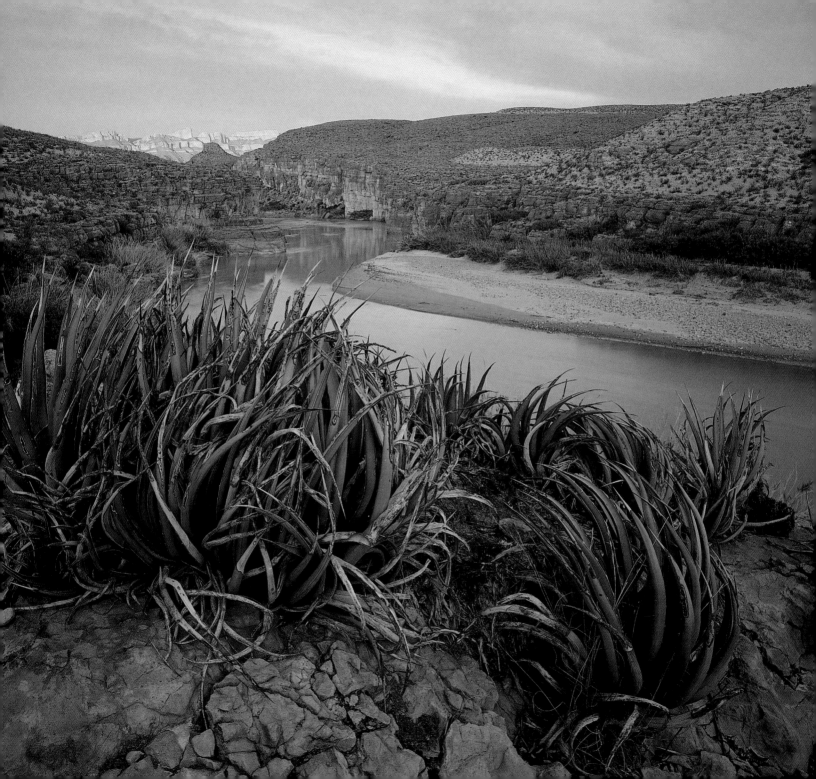

Facing page: Lechuguilla, an indicator plant of the Chihuahuan Desert, grows in abundance on the limestone bluffs above Hot Springs Canyon. STEVE GUYNES

Right: A somber, yet simple, memorial to a fallen resident of Glenn Springs. STEVE GUYNES

Below: Grapevine Hills, known for captivating rock formations. STEVE GUYNES

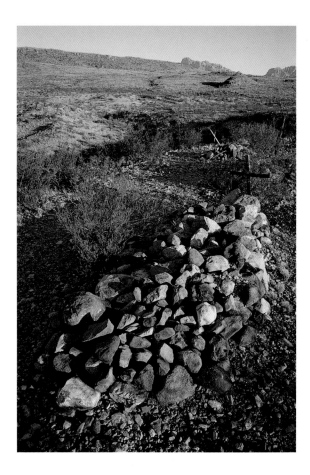

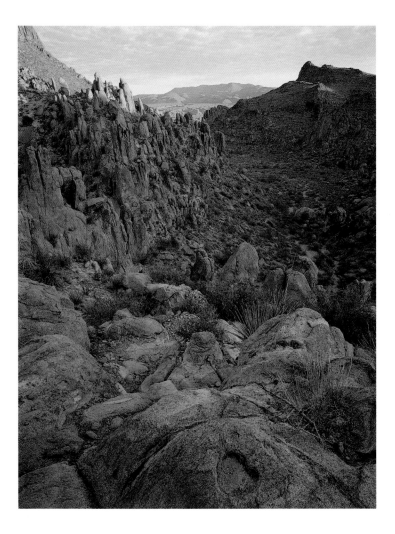

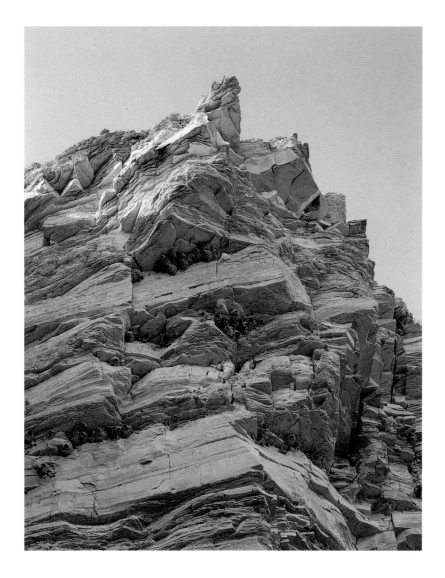

Above: Cliff swallows cleverly construct colonies of mud nests under rock ledges.
STEVE GUYNES

Right: Some of the many unique sandstone formations in the Chihuahuan Desert.
RICHARD REYNOLDS

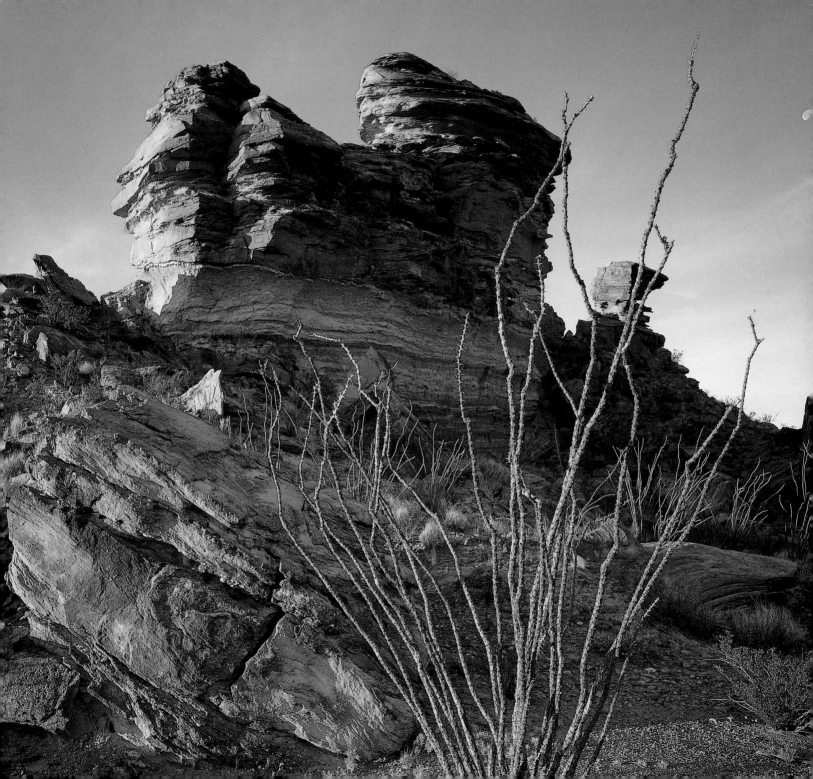

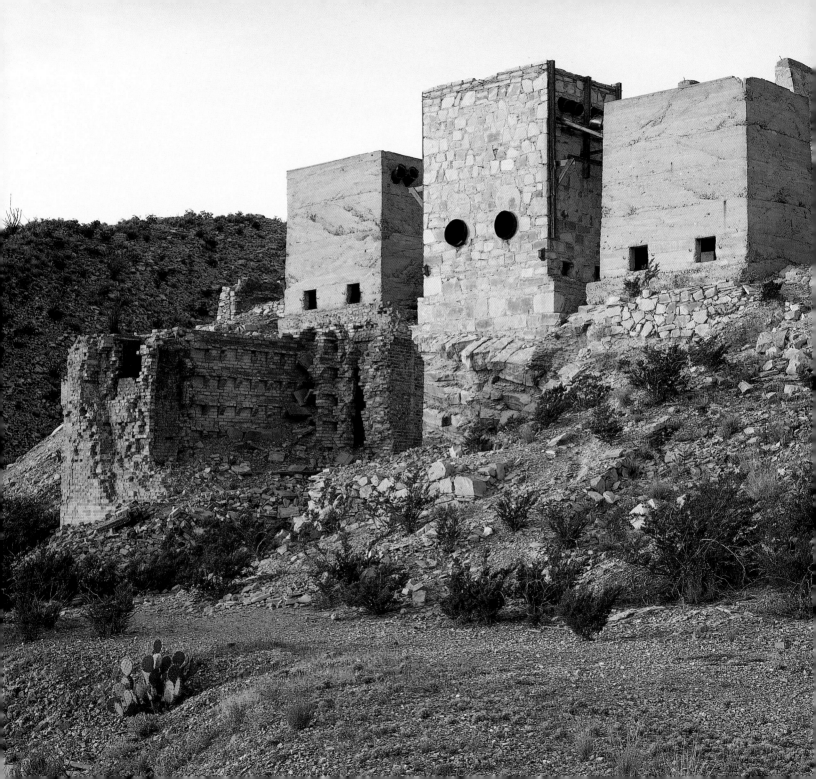

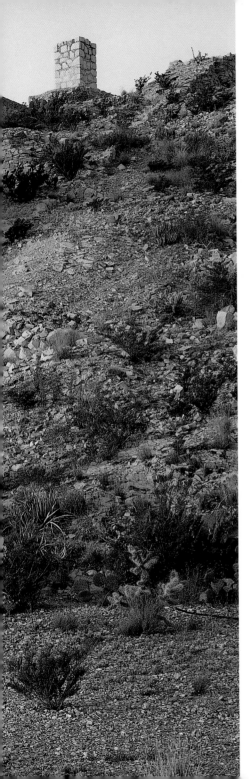

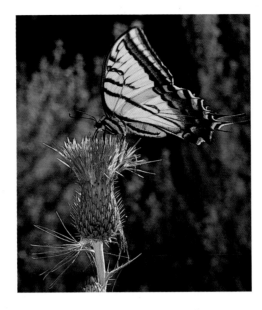

Far left: Remnants of the Mariscal Mine.
STEVE GUYNES

Left: A two-tailed swallowtail alights on a wavyleaf thistle. KATHY ADAMS CLARK

Below: Edwards' hold-in-the-sand plant mingles with Graham dog cactus.
RICHARD REYNOLDS

Facing page: These prickly pear cacti seem to gaze up at towering Cerro Castellan. RICHARD REYNOLDS

Below: The stunning view of the Sierra del Carmen from the Rio Grande Village overlook. STEVE GUYNES

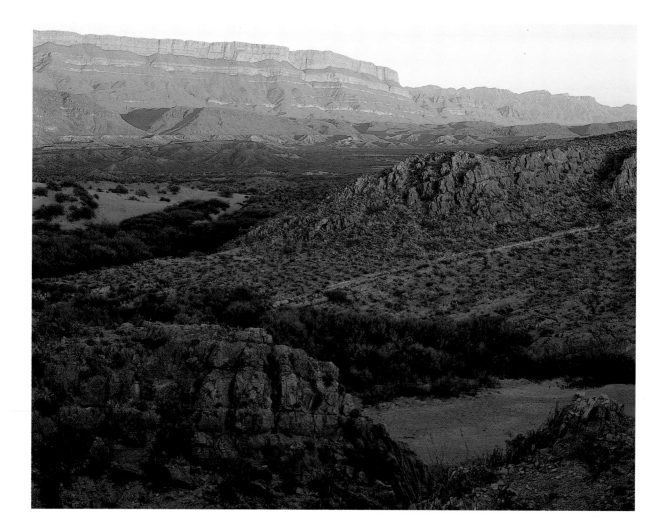

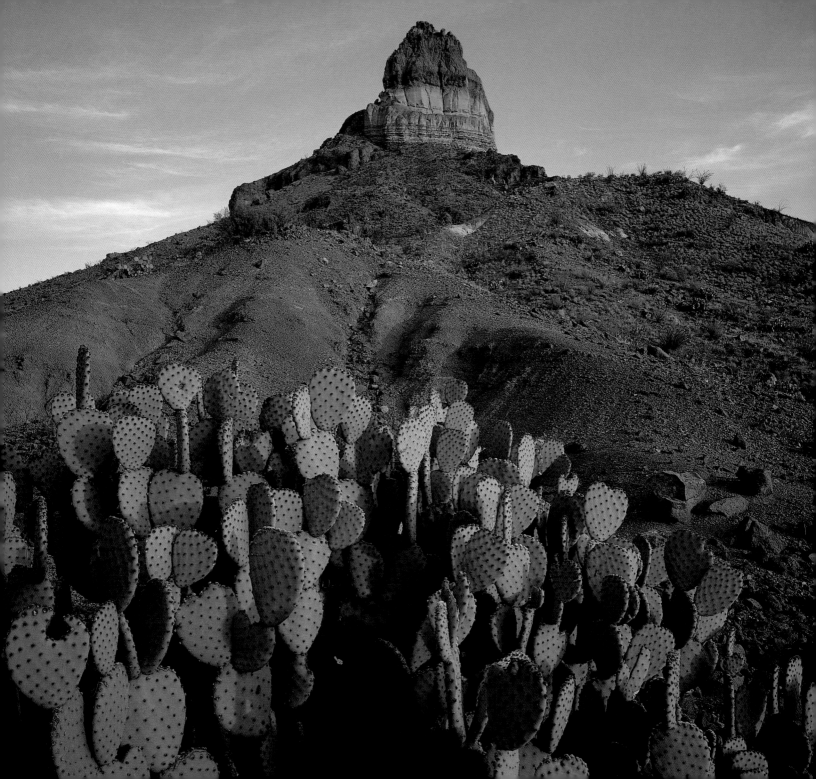

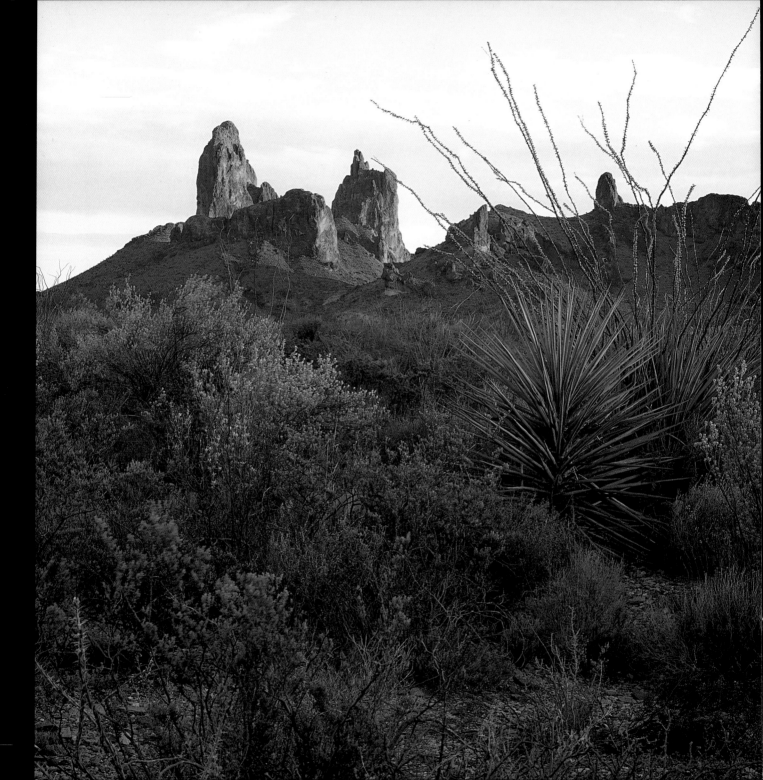

Left: Mule Ears, twin peaks of black rock, mark where two igneous dikes meet. STEVE GUYNES

Below: Black-tailed jackrabbits are common denizens of the desert scrubland. KATHY ADAMS CLARK

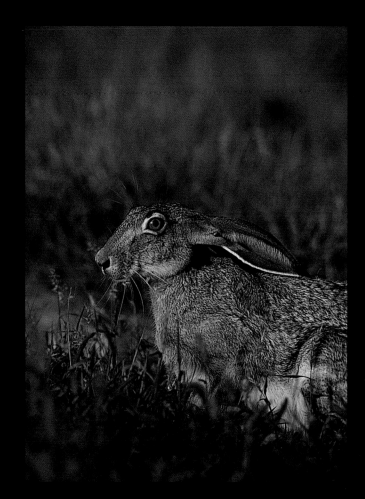

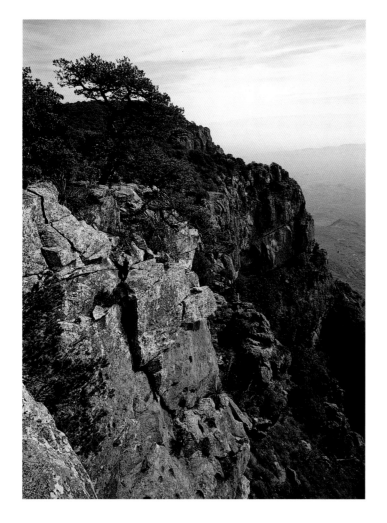

Above: Many kinds of vegetation manage to thrive on the rocky South Rim of the Chisos Mountains. STEVE GUYNES

Right: The flowering spikes of sotol rise above rosettes of toothed leaves. RICHARD REYNOLDS

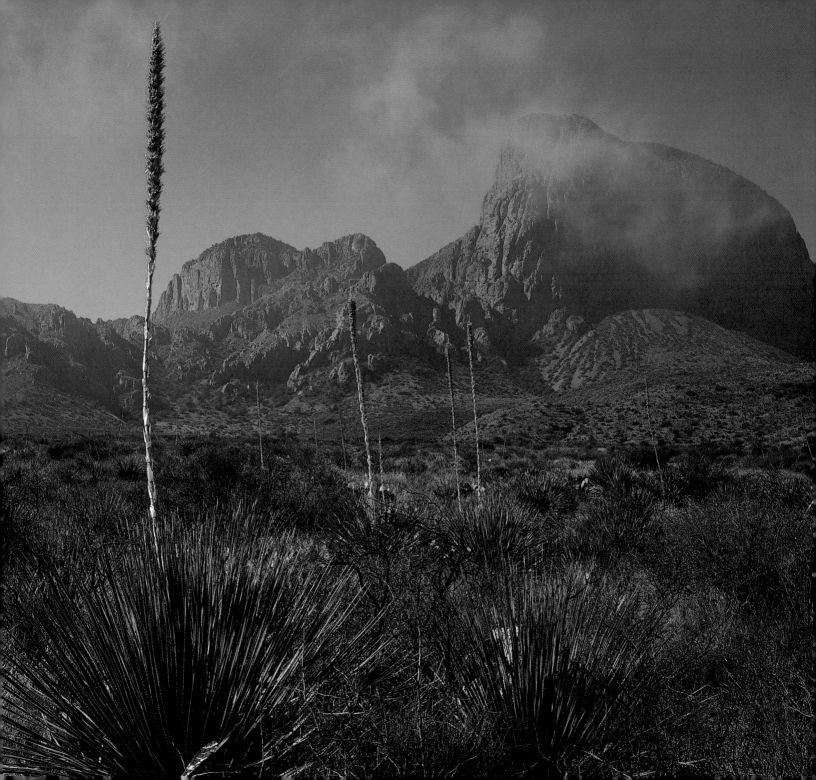

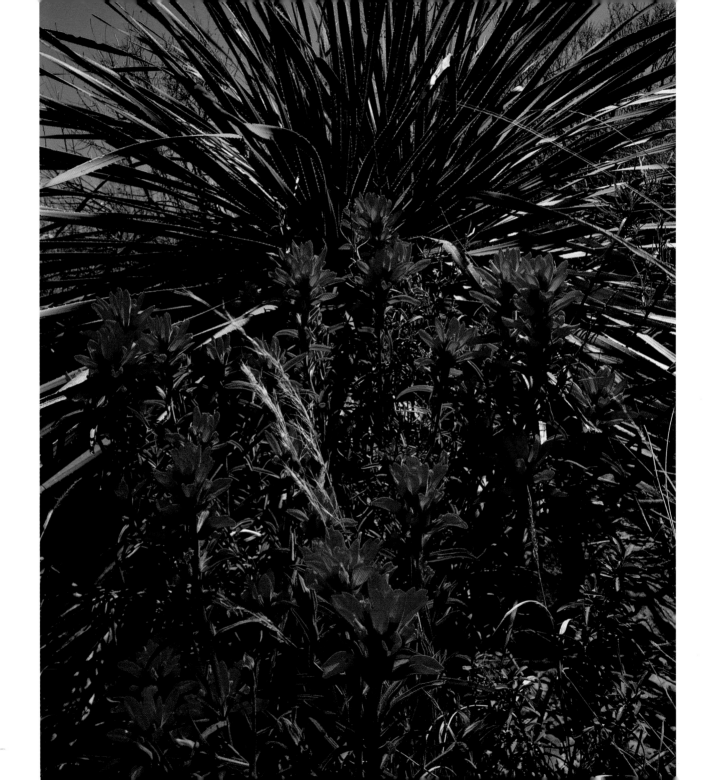

Facing page: A giant Indian paintbrush shares its sunny desert real estate with this sotol plant. RICHARD REYNOLDS

Left: Hummingbirds are the primary pollinators of the claret cup cactus, which dusts the birds' heads with pollen as they reach deep into the flower for nectar. STEVE GUYNES

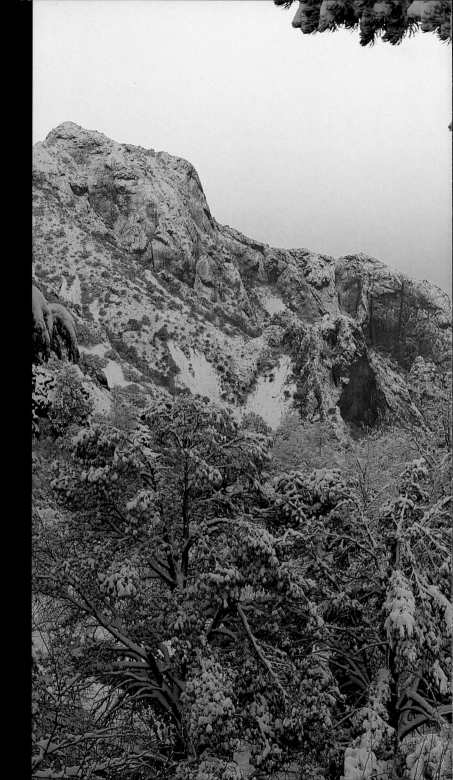

Chisos Basin trees shrug under
the heavy weight of wet snow.
RICHARD REYNOLDS

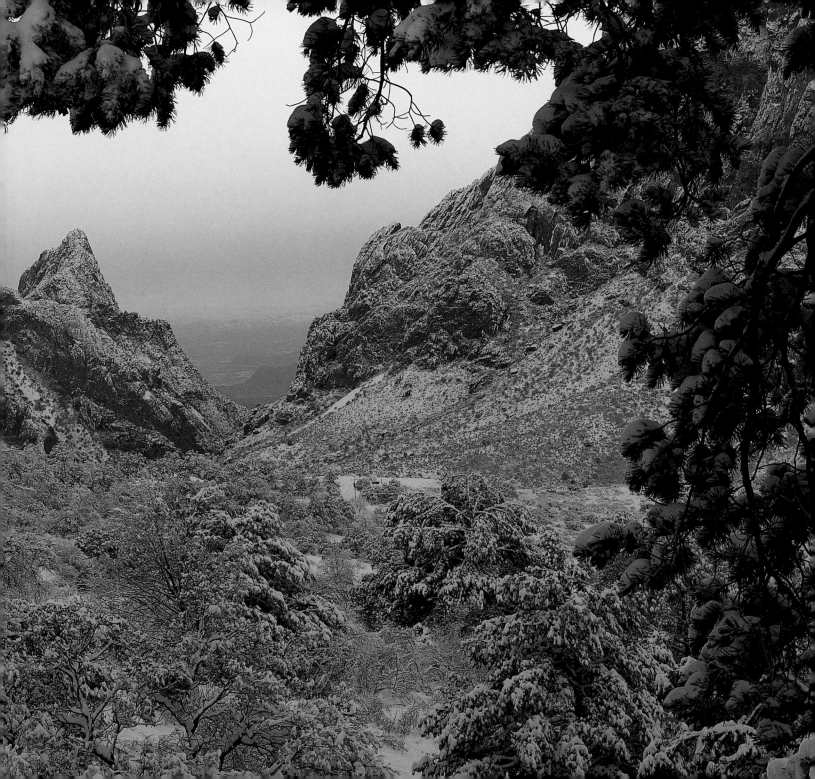

© SHARON GUYNES

Steve Guynes

Plano, Texas, landscape photographer Steve Guynes has been chasing the light with his 4x5 and 8x10 cameras for almost twenty years. Although he has photographed subjects across the United States, his emphasis has always been on the Texas landscape.

Steve is a part-time freelancer/fine art photographer and full-time structural engineer. His color work has appeared in numerous calendars and in *Texas Highways* and *Texas Parks & Wildlife* magazines. He has had several one-man shows of his black-and-white photographs.

Richard Reynolds

Richard Reynolds earned a degree in industrial photography and color technology at the prestigious Brooks Institute of Photography in Santa Barbara, California. His photographs have appeared in numerous state, national, and international publications including *National Geographic Traveler, Newsweek, Outside Magazine, Texas Monthly, Readers Digest, Southern Living, Vista, Geo* (France), and *Richtig Reisen Texas.* He is a regular contributor to *Texas Highways,* where he has more than twenty-five covers to his credit. In addition, his work has appeared in dozens of calendars by Sierra Club, Westcliffe Publishers, Brown Trout, Golden Turtle, and Shearson Publishing. He is also the photographer of six other books: *The Green Pastures Cookbook; Texas, Images of Wildness; Texas Reflections; Texas Wildflowers; Texas Hill Country;* and *A Texas Christmas.*

© MICHAEL MURPHY